Photographing Arts, Crafts & Collectibles

Photographing Arts, Crafts & Collectibles

Take Great Digital Photos for Portfolios, Documentation, or Selling on the Web

Gloria H. Conwell, artist

LARK BOOKS

A Division of Sterling Publishing Co., Inc.
New York / London

Steve Meltzer

Book Design and Layout: Tom Metcalf
Cover Design: Thom Gaines
Associate Art Director: Lance Wille

Library of Congress Cataloging-in-Publication Data

Meltzer, Steve.
 Photographing arts, crafts & collectibles : take great digital photos for
portfolios, documentation, or selling on the web / Steve Meltzer. — 1st ed.
 p. cm.
 Includes index.
 ISBN 1-57990-906-X (pbk.)
 1. Photography—Digital techniques—Handbooks, manuals, etc. 2. Digital
cameras—Handbooks, manuals, etc. 3. Image processing—Digital
techniques—Handbooks, manuals, etc. 4. Advertising photography—Handbooks,
manuals, etc. I. Title. II. Title: Photographing arts, crafts, and
collectibles.
 TR267.M48 2007
 775—dc22

 2006037409

10 9 8 7 6 5

Published by Lark Books, A Division of
Sterling Publishing Co., Inc.
387 Park Avenue South, New York, N.Y. 10016

Distributed in Canada by Sterling Publishing,
c/o Canadian Manda Group, 165 Dufferin Street
Toronto, Ontario, Canada M6K 3H6

Distributed in the United Kingdom by GMC Distribution Services,
Castle Place, 166 High Street, Lewes, East Sussex, England BN7 1XU

Distributed in Australia by Capricorn Link (Australia) Pty Ltd.,
P.O. Box 704, Windsor, NSW 2756 Australia

If you have questions or comments about this book, please contact:
Lark Books
67 Broadway
Asheville, NC 28801
(828) 253-0467

Manufactured in China

ISBN 13: 978-1-57990-906-2
ISBN 10: 1-57990-906-X

For information about custom editions, special sales, premium and corporate purchases, please contact Sterling Special Sales Department at 800-805-5489 or specialsales@sterlingpub.com.

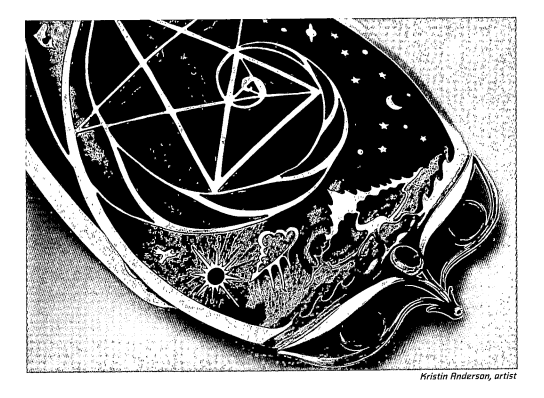

Kristin Anderson, artist

Acknowledgment
The photographs in this book illustrate the work of dozens of artists,
and I want to thank all of them for allowing me to reproduce the
images of their work in this book. These photos are as important as the
text in explaining how to shoot these pieces.

Dedication
For Connor, Alyx, Mike, and Diane

contents

Photography is about using light to record images. In that sense, it really hasn't changed much in the nearly two centuries since William Fox Talbot, the inventor of the negative process, started photographing the people, places, and things that filled his world.

The subject of this book is the photography of things, which is different in many respects than trying to photograph people and places. This is a hands-on, practical guide. I'll tell you what works and what doesn't work, based on my experience in this area of photography. I've been a professional photographer for thirty years and have worked with computers since the 1960s.

Photography is a mixture of art and technology, a combination that is confusing at times. Terms and techniques are thrown together in a language soup in which one word may mean several things. I'll try my best to cut through the jargon, define the terms, answer questions, explain how to use lighting and backgrounds for dramatic effect, and to help you fine-tune your digital images. You'll learn techniques for taking pictures of different kinds of objects, as well as tips for using those images to market your art, craft-work, or collectibles.

As you read this book, you'll realize that I strongly believe the way to make better photographs is to make lots of them. Try things and give yourself permission to make mistakes.

Such permission is perhaps digital photography's greatest gift. Unlike film, digital mistakes don't cost anything. You can do things repeatedly until you get them right. Thanks to the digital camera's delete button, if a picture is not up to your standards, you can simply press the little trash can icon and move on. It's free and it makes photography less stressful and more fun. Plus, seeing something that's not quite right while you are still working on the images is the best way to learn.

And that's what it's all about, having fun while learning new things.

Steve Meltzer

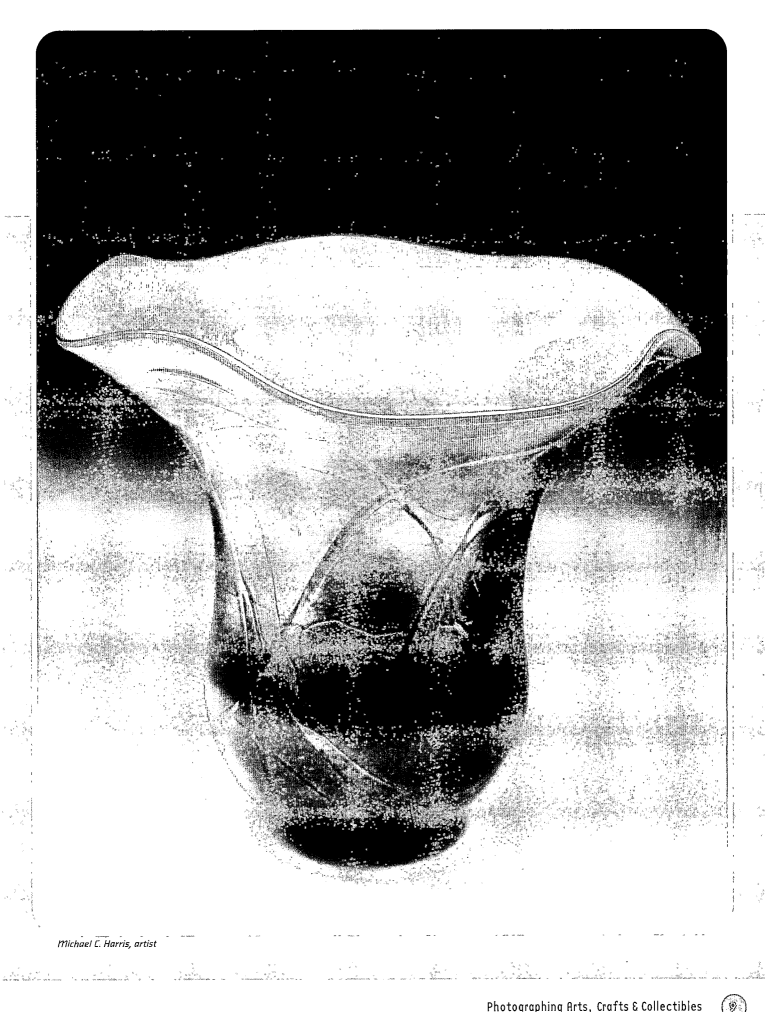

Michael C. Harris, artist

an overview of digital photography

There are a number of similarities between digital cameras and traditional film cameras. Both are dark boxes that hold a lens and focus an image. You operate both in much the same way. However, there are also fundamental distinctions. Film images are recorded on film and developed at a later time with chemicals. They are stored as analog information–a direct record of the color and intensity of the light that falls on the film substrate. The revolutionary difference with digital technology lies in the way digital cameras record light and store the captured image: The light is recorded by the sensor, processed electronically, and converted into a digital image. The red of a flower is not red dye, but millions of lines of numbers. Thanks to powerful computer chips, these huge files can be easily converted into areas of color that we can see on a computer monitor or in a print.

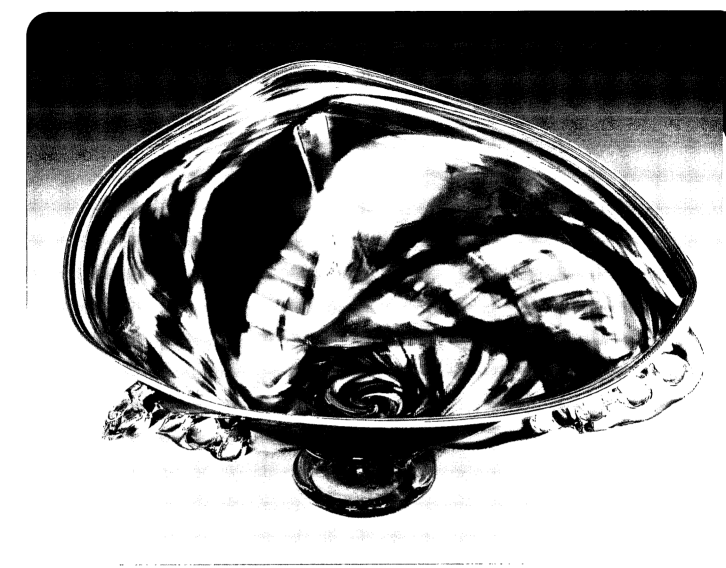

Photo quality is outstanding with digital cameras. Of course you still need to learn good lighting techniques and how to set your camera properly in order to get the best pictures possible.

The Digital Camera

D igital cameras have several advantages that have helped them supplant film cameras over the past few years. The ability to immediately review your pictures on the camera's LCD monitor, to change ISO settings from picture to picture, the durability and reusability of memory cards, and the chance to examine histograms to fine-tune exposure have helped digital photography become very popular. But to take a closer look at some of the ways a digital camera is different than a film camera, we can actually start with one thing that both types have in common–the lens.

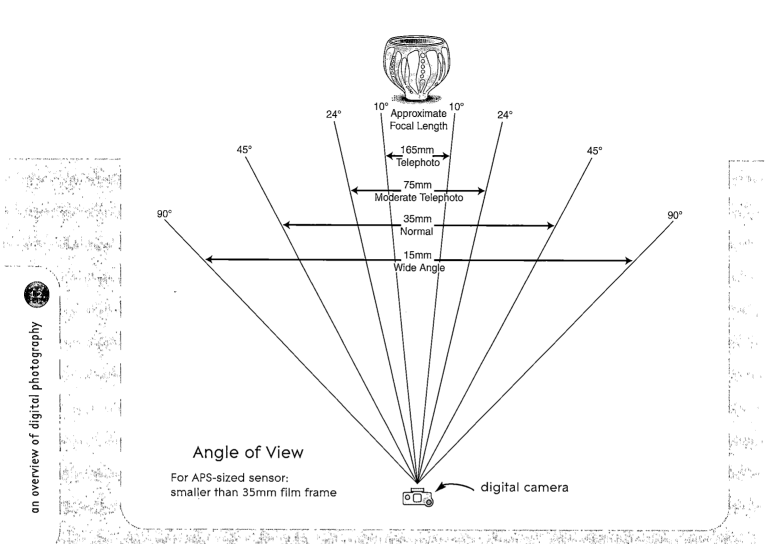

Angle of View

For APS-sized sensor:
smaller than 35mm film frame

The Lens

The purpose of the lens is to sharply focus light. While far more sophisticated, today's camera lenses are similar to the first ones used in photography in the 1840s. They are made of glass (or plastic) elements mounted in a tube that can be moved to focus an image on a surface.

When light falls on an object, some is absorbed and some, which contains information about the color and shape of the object, is reflected in all directions. It's the job of the lens to bring order to this array of light by bending and organizing the rays until they exit the lens as an orderly bundle that produces a sharp image on a surface. In the case of a camera, that surface is a light sensitive recording device: film or sensor. The lens on the camera is a critical factor contributing to the quality of the final image.

Focal Length

One way to describe a lens is by its focal length, which is derived from the distance between a point in the lens (node of emission) to the focused image on the sensor or film (focal plane). Focal length is denoted in millimeters (mm). That's technical, but the important thing to realize is how focal length affects the scale of objects in the image. The longer the focal length of a lens, the more magnified the objects appear in the image and the narrower the area recorded (angle of view). On the flip side, lenses with smaller focal lengths give a wider angle of view, and objects consequently appear more distant and smaller.

All lenses project a certain image size of the subject onto the camera's focal plane. The size of the subject is the same for any lens with a given focal length, whether that lens is mounted on a view camera, a medium format camera, a 35mm film camera, or a digital camera.

This series of object photographs demonstrates how angle of view changes when a sensor smaller than a 35mm film frame is used. With film, the image focused by the lens covers the entire film frame: about 43 – 44 mm (1.7 inches) across the diagonal. While some digital cameras have sensors this size, most sensors in digital cameras are smaller, creating a smaller area for the image. So when lenses with the same focal length are used on both a 35mm and a digital camera, the projected image remains the same size but appears effectively bigger in the digital camera's viewfinder because it fills more of the camera's smaller frame. The lens effectively has a smaller angle of view, like a crop from the center of the larger format, giving a telephoto effect. In addition, sensors in different cameras can be different sizes, so image areas for a specific focal length may also be different among various digital cameras.

Photos © Simon Stafford

Digital camera manufacturers often talk about their lenses as having 35mm equivalent focal lengths. These give photographers familiar with 35mm film format a guide to compare the view from a lens with a particular focal length used on the newer format (sensor size). Since the active image area on most sensors is smaller than 35mm, you can approximate the lens' angle of view by multiplying its focal length by a "magnification factor." This will tell you which focal length lens on a 35mm camera would yield about the same view. Different sensors require different magnification factors,

sometimes called multiplier factors. For digital single-lens-reflex cameras (D-SLRs), the magnification factor is usually close to 1.5x. Thus a 50mm lens on a D-SLR might give you an angle of view that is the same as a 75mm lens on a 35mm film camera. Many point-and-shoot digital cameras have even smaller sensors, and therefore have larger multiplication factors.

TAKE A WALK ON THE WIDE SIDE.

Despite the wonders of digital photography, photographers who like to shoot with wide-angle lenses on their traditional 35mm film cameras have taken a hit. Because of sensor size, the angle of view for lenses with these focal lengths is reduced when used on most digital cameras. To continue to shoot wide images, photographers can take advantage of new, short focal length lenses made specifically for digital cameras.

Most point-and-shoot and EVF digital cameras have zoom lenses that offer a moderate wide-angle field of view. One way to expand the wide-angle ability of these cameras is to get an accessory called a wide-angle converter that screws onto the front of the camera's lens. This optical compromise alters the field of view before light enters the lens.

Categories of Lenses

Go to any camera store and you will see dozens of lenses with a wide assortment of focal lengths. But all of these fall into a few basic categories. For the photography of objects, the most useful focal lengths are found in moderate telephoto lenses or in zoom lenses used at a moderate telephoto setting.

Wide angle: These have short focal lengths (typically about 5 to 15mm with point and shoot cameras and about 12 to 35mm with other types of digital cameras) and a broad field of view. There are also extreme wide-angle lenses called "fish-eye" lenses that produce up to a 180° circular image in the camera frame. Wide-angle lenses are useful in the photography of interior spaces and landscapes. However, photographs taken with wide-angle lenses can alter images in certain ways. One is the exaggeration of perspective—near objects will appear larger than more distant ones.

Normal: Sometimes called standard lenses, these see objects near and far in about the same relationship and size as we normally see with our eyes. The normal focal length for digital SLRs with smaller format sensors is between approximately 36 and 40mm, or about 50 to 60mm on full-frame D-SLRs.

Telephoto: These lenses are telescopes. With a narrow angle of view, they make distant objects appear closer while compressing distance, so that near objects seem to be closer to distant objects than they are in reality. For most D-SLRs, moderate telephotos have focal lengths between 40 and 90mm, and anything greater is considered a long telephoto.

Zoom: A zoom lens can be set to different focal lengths. The focal lengths of a zoom are expressed as a range from shortest to longest (e.g. 5.4-16.2mm or 35-105mm), and the lens can be set to various focal lengths within that range. This is probably the most popular type of lens in digital photography. Manufacturers sell zoom lenses with many different ranges of focal lengths for D-SLRs, while most non D-SLR digital cameras are equipped with a permanent zoom lens.

Macro: Designed to let you take close-up pictures, true macro lenses are flat field and can focus continually from the front element of the lens to infinity. A number of cameras have zoom lenses with a setting for macro or close focus, but these aren't the same as macro lenses.

storage
(buffer and memory card)

image sensor

light rays lens

A/D converter

aperture shutter

Basic Operation of a Digital Camera

image processor

The Sensor

The sensor is an integrated circuit board composed of millions of photodiodes called picture elements (pixels). It records the various intensities of light (energy) falling on it. There are several types of sensors made for digital photography: the Charge Coupled Device (CCD), the Complementary Metal Oxide Semiconductor (CMOS), the Negative-Channel Metal Oxide Semiconductor (NMOS), and the Positive-Channel MOS (PMOS). Each type has its supporters and detractors. They all work well and record perfectly wonderful pictures. When considering the factors that produce good photographs, the type of sensor isn't as big a factor as the quality of the lens.

What matters, for enlarging and printing the image, is the number of pixels on the sensor. This number is one way in which digital cameras are defined. For example, a camera with a sensor possessing 6 million pixels is called a 6 megapixel (MP) camera. The total number of pixels on the sensor is its resolution. Generally, the higher the resolution, the finer the detail the sensor can record, and the larger you can ultimately print the image.

Like film, a sensor has a contrast range that limits its ability to record big differences in exposure, especially when it comes to bright lights. Sensors are like slide film in that very bright areas in a scene tend to burn out, lacking color, detail, and texture. We will look at how to match the contrast range of the scene you are shooting (objects with backgrounds) with the recording range of the sensor.

HOW MANY MEGAPIXELS DO YOU NEED?

One issue that faces all buyers of digital cameras is determining what resolution (how many megapixels) is needed. That depends on the uses you have for photographs. If you primarily plan to make 4 x 6 inch color prints (10.2 x 15.2 cm) and photos for the Internet, don't buy a big 10 or 12 MP camera. That is like shooting a mosquito with a cannon. You'll be paying for pixels you will simply never use. A more appropriate choice would be to buy a 5 or 6 MP camera. With these size files, you can easily produce web images and small prints, and you'll also have plenty of pixels for that special 8 x 10 inch (20 x 25.4 cm) or 11 x 14 inch (28 x 35.5 cm) color print for the wall. If you plan to turn your files into big prints, or to publish them, then an 8 MB or higher camera would be more useful.

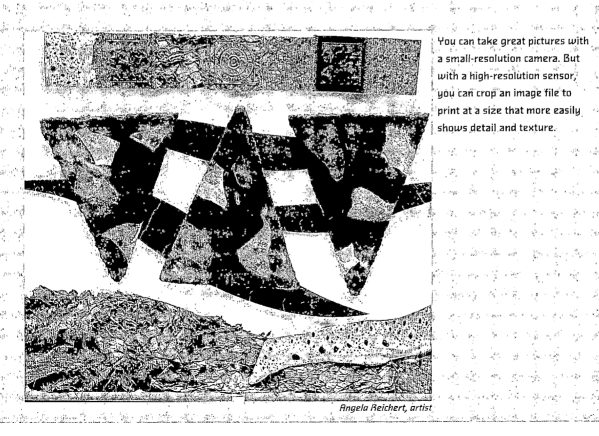

Angela Reichert, artist

You can take great pictures with a small-resolution camera. But with a high-resolution sensor, you can crop an image file to print at a size that more easily shows detail and texture.

The Analog-Digital Converter

The pixels on a sensor record the intensity of light and turn that energy into analog electrical signals, but computers can't use analog data. It is the Analog-Digital (A/D) converter that processes the continuous analog signal from the sensor into bits of digital information and assigns each one a binary label that the computer can read.

The Image Processor

The image processor, sometimes called an image engine, takes the pieces of data from the A/D converter and stitches them together to form an image file. All digital information consists of long strings of numbers made up of thousands or millions of bytes (KB or MB, respectively). Each bunch of numbers is organized as a file with an identifying extension

BITS, BYTES, AND BINARY NUMBERS

Normally we count in a mathematical system called base ten. Simply put, there are just ten numbers (0 – 9) that are combined to make all other numbers. Digital information, on the other hand, consists of a base two system, in which the only numbers are 0 and 1. All values are denoted as a combination of these two. The zeroes and ones are in groups of eight called a bit, and they can represent a number, a letter, or a sign (like % or #). Stringing eight bits together creates a byte. The number one (1) for instance, in a binary system, is represented by 00000001, while the number two (2) is 00000010.

designation so the computer can decipher the information. To tell the computer that this is a photograph, the file extension will be .gif .tif, .raw or .jpg. If it's a music file, the extension will be .wav or .mp3. There are many types of text files with extensions like .doc, .txt, or .wps.

The image processor applies the camera settings you've selected, such as white balance and image size, and configures the image files using its built-in software programs (firmware) as a .raw, .jpg, or .tif file. (See pages 26-28 for more details on file types and image size/quality).

The Buffer

The buffer temporarily stores the file. Most digital cameras do not have built-in memory, so the image files have to be written to storage devices called memory cards to be saved. But image processors work fast—much more quickly than files can be recorded to the memory card. Rather than shut down the camera while a file is being written, the image engine parks them in the buffer where they wait momentarily while being recorded to the memory card. In the meantime, you can continue taking pictures. unless the buffer is full.

Usually a camera will take a certain type of memory card, though some cameras are able to use multiple card formats. The CompactFlash card (CF) is a little larger than the Secure Digital (SD) card.

The Memory Card

The memory card stores digital files. It's an integrated circuit chip that is non-volatile. That simply means that it retains information even when there is no electric current. The random access memory (RAM) on your PC, on the other hand, is volatile and loses its stored data when the power goes off.

Memory cards are about the size of a thin matchbook or postage stamp and are fairly rugged. There are several types commonly used in digital cameras, including CompactFlash (CF) Type I and Type II, Secure Digital (sD), xD, and Memory Sticks from Sony. Each type is physically distinct and not interchangeable. While some digital cameras can use a couple different kinds, most use one type of card and no other.

Memory Card Storage Capacity

These cards are available in various storage capacities. The total number of images you can save on a memory card depends not only on the capacity of the card, but also the type of files you are saving, their resolution, and how much you've compressed them. Even the subject matter of your photo can affect the size of a file because a picture with lots of smooth tonal areas will produce a smaller file than one with a number of different tones. How large a memory card do you need? That will partially depend on your shooting style. If you have an 8 or 10MP sensor and you like to record RAW files, you may want a 2 Gigabyte (2 GB) or larger memory card. I only shoot JPEGs when using a 6MP camera or smaller, in which case a card with 512MB may be enough.

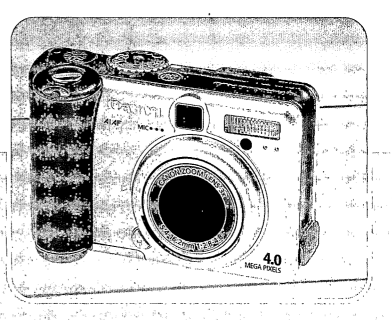

Types of Digital Cameras

All digital cameras use a lens and have a sensor, an analog/digital converter, and an image-processing engine. But there are different types of digital cameras currently available. One convenient way to understand the differences in digital cameras is to look at the way they let you view and compose an image. Categorizing cameras this way separates them into three distinct groups.

Digital Point-and-Shoot Cameras

Small and convenient, point-and-shoot cameras are primarily designed for snapshots, family photos, party pictures, and vacation images. Most are best when used for making small prints and for sharing images on the web.

Point and shoots have either no viewfinder or just a simple optical glass viewfinder. This is usually above and to the side of the lens, so you won't see exactly what the lens sees, making accurate framing difficult. Therefore, composing and framing is often done using the LCD monitor on the back of the camera. This is especially useful in close-up photography.

These cameras are usually the least expensive and simplest to operate. The more basic models have sensors of relatively low resolutions, generally 4MP or less. Most have a permanent zoom lens that goes from a moderate wide-angle to a moderate telephoto focal length. Although many brands offer excellent point-and-shoot cameras, the options, features, and lens quality vary widely among different models and price points.

Can you use this type of camera for the photography of objects? That is not the purpose they are designed for and their limitations will make the work harder. Point-and-shoot camera lenses are generally not as good as those on more sophisticated cameras, and most lack a true close-up capability, so can't be used with small objects. The small viewfinders are not good for accurate framing or accurate focusing. Even using the camera's LCD monitor may not always be convenient because most screens are too coarse (not high enough resolution) to really tell if you are correctly focused, and many are hard to see in bright light. Also the very small cameras may be too small to hold steady, making framing and sharpness a problem. But if your needs are modest—small prints, or images for Internet selling or for email—a point and shoot may do the job.

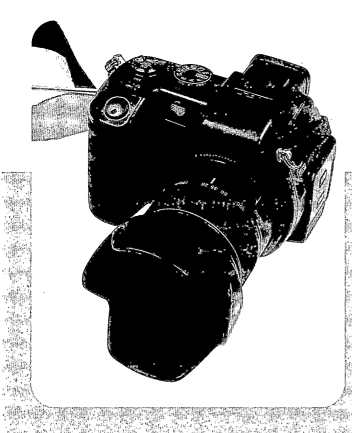

EVF Cameras

This type of camera utilizes an electronic viewfinder (EVF, like a little TV screen in the viewfinder) for framing your pictures. These cameras offer a number of advanced capabilities in a compact package aimed at advanced amateurs. EVF cameras are also known by different names, such as advanced compact, advanced digicam, all in one (in U.S.), or bridge cameras (in Europe). I call them EVF cameras because the electronic viewfinder is the attribute that sets them apart from all the other cameras.

Most EVF cameras have sensors (often with resolution between 6 and 10 MP) and permanently mounted, non-interchangeable zoom lenses that are higher quality than those found in most point-and-shoot cameras, with zoom ranges that often extend from wide angle to long telephoto. This makes them first rate, versatile cameras that give sharp images. Many EVF cameras have usable macro settings for close-up work, although such settings on some of these cameras are easier to operate than on other cameras. So check out the close-focusing features of the specific camera model that interests you.

Generally priced between point-and-shoot and D-SLR cameras, the EVF camera is perfect for anyone who wants a camera that is more versatile than a point and shoot but doesn't have the extra expense of a D-SLR outfit. However, some of the viewing screens in EVF cameras are too grainy and hard to use for focus and composition due to their low resolution. On some EVF cameras, the screen image blurs as you move the camera, or it freezes when you take a photo. Newer EVF camera models have cleared up some of these problems, and further improvements are sure to arrive soon. I have both EVF cameras and D-SLRs and find they work equally well for most photography of objects.

One problem for some photographers is the fixed zoom lens. EVF cameras lack the versatility of D-SLRs with their interchangeable lenses. But there's nothing inherently wrong with a fixed lens camera. If you aren't planning to build a camera system with multiple interchangeable lenses, a good fixed zoom will do most everything you want. In fact, a permanently mounted lens helps to protect the sensor from dust since the sensor is never exposed to the environment when changing lenses, as would happen with a D-SLR. EVF models are also usually lighter and smaller than D-SLRs, which can be desirable when traveling.

Most EVF cameras have built-in flashes, and some have hot shoes and/or PC plugs that allow you to use portable electronic flashes or studio strobes. In addition, not only do they record high-quality JPEG files, they often have the capability to record RAW photo files, a file type that lets the photographer rather than the camera process the digital data.

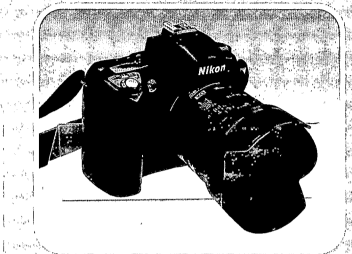

Digital Single-Lens-Reflex Cameras (D-SLR)

A single-lens-reflex camera lets you see exactly what the lens sees. D-SLRs are popular in part because of their versatility. For professionals who must shoot different types of subjects under a variety of conditions, only the digital single lens reflex has the flexibility and quality they demand.

The single lens part of the name comes from the 1950s and was used to differentiate SLRs from the twin-lens cameras of the day, like the Rolleiflex. SLRs have a mirror behind the lens that reflects the light coming through the lens, often into a pentaprism viewfinder system (hence the "reflex" part of the name). Looking into the viewfinder, the photographer sees exactly what the lens sees. Press the shutter release and the mirror flips out of the way (on most SLRs) as the shutter opens to allow light to strike the sensor.

D-SLRs usually have hot shoes and most have PC plugs so you can use them with studio flashes. Another important characteristic of the D-SLR is its interchangeable lens. The photographer can take a lens off the camera and replace it with a lens of a different focal length or specialization. Most manufacturers offer a wide variety of interchangeable lenses for their D-SLRs. But interchangeable lenses can be expensive, some costing as much or more than a D-SLR camera body. Before getting a D-SLR, consider the total cost of the body with additional lenses against your true photographic needs.

D-SLR cameras with 6–10MP resolution sensors cost between $500 and $1000 (some with lens included, some sold as body only), while 12MP and larger D-SLRs are in the $1500 to $5000 range.

Most manufacturers use a lens mount on their digital cameras similar to that used on their film cameras, which means older "film" lenses can, with a few provisos, be used on their D-SLR models. This is good news for photographers who have an investment in lenses for 35mm film cameras from these manufacturers. There are a few problems though. Older lenses may not have the electrical contacts needed for complete automation on the digital camera. Without these contacts, some older lenses won't work with the camera's autofocus and autoexposure systems. Photographers with older lenses need to research how compatible these lenses will be with their digital camera.

Digital Camera Features and Operations

Digital cameras have a group of parameters called defaults that control their settings when you first turn them on. These defaults are designed for general photography. However, if you want to shoot photos that are more than mere snapshots, you'll want to learn to control the camera yourself. An important feature in digital cameras is the menu system. Viewed on the LCD, it is usually activated by pressing the MENU button found on the body of the camera. Menus allow you to set many of your camera's functions and modes, as do the buttons and dials found on the camera body. It is essential to understand how to operate your particular camera's menus and controls so you can make the desired settings quickly and efficiently.

Image Size

Your digital camera's image sensor will probably have a resolution between 4 – 10 megapixels. This number is the largest file your camera can create, and most of the time you should use this maximum image size or resolution. Your camera might denote this as "large," or perhaps with a numerical representation of the number of pixels in the photo files, for instance 3264 x 2448 (width x height in pixels) for an 8MP camera. These are big files that take up a lot of room on your memory card.

Most digital cameras offer a choice of different image sizes. Selecting the image size, or resolution, is an important decision. There are usually several lower-resolution settings available as well as larger files, with the lowest option often about 300KB (640 x 480 pixels). When I'm shooting images just for the web (to share with family and friends or as samples for clients), I always use the lowest resolution. It records a small file that will upload and download quickly and produce a sharp, clear image that just about fills a PC monitor screen. But, as I said earlier, generally the highest resolution setting is the best choice.

Aspect Ratio

This is the relationship between the length of the image frame and its height. There are three aspect ratios normally used for digital sensors: 3:2, 4:3, and 16:9. Of course, you can always crop a picture to any aspect ratio you wish with image-processing software in your computer, but if your camera offers the option, setting it for a particular aspect ratio can help in framing and composing your pictures. You may want to think about aspect ratios based on their strong and weak points as described below when you are considering a camera to buy.

3:2 Aspect Ratio

This is the aspect ratio used in 35mm film and is consequently the aspect ratio of choice for many digital photographers who learned their craft with 35mm photography. It is the standard frame ratio in many D-SLRs. While 3:2 is the right aspect ratio of a 4 x 6 inch (10.2 x 15.2 cm) print, the other standard sizes must be cropped. If you plan to output slides from digital images, this is the format to use.

4:3 Aspect Ratio

The 4:3 can be found in point and shoot and EVF cameras, and some D-SLRs. It is derived from the old APS (Advanced Photo System) film frame. With this aspect ratio, you can make uncropped prints of 4 x 3 inches (10.2 x 7.6 cm) or 8 x 6 inches (20.3 x 15.2 cm), or other corresponding proportions. Notice that none of these sizes match the standard print sizes of 3.5 x 5 inches (8.9 x 12.7 cm), 4 x 6 inches (10.2 x 15.2 cm), 5 x 7 inches (12.7 x 17.8 cm), or 8 x 10 inches (20.3 x 25.5cm). But the 4:3 is the aspect ratio of the standard letter size of 8.5 x 11 inches (21.6 x 27.9 cm), and that makes it useful for many photographers.

16:9 Aspect Ratio

Finally, some cameras, notably those from electronics companies like Panasonic, offer a sensor with a 16:9 aspect ratio. This is the shape of many letterboxed movies, the new widescreen computer monitors, and high definition televisions (HDTV). It is wider and shorter then the other formats and must be cropped to make any standard size print. However, it is a wonderful format for landscape photography or for digital "slide" shows that fill your HDTV screen with breathtaking images, but it is not very useful for the photography of objects.

Image Quality
and File Type

Image quality (sometimes just called quality) is an option often found in the menu system. It allows you to choose the file type, and in the case of JPEG, the level of compression for the image you plan to shoot. There are several common file types utilized by digital cameras.

JPEG

JPEG (Joint Photographic Experts Group file, pronounced "jay-peg" and abbreviated with the file extension .jpg) is a standard for compression and also one of the oldest of the image file writing systems. This standard was created as a way to pack large digital images into small file sizes using lossy compression. The processor looks for redundant data and discards it during file compression. It rebuilds the data when the file is decompressed. This process makes files easier to store and transmit. In most cameras, there are several levels of JPEG compression from which to choose: low, medium, and high. The higher the compression, the smaller the image file and the more detail the photo loses. The biggest advantage of JPEG files is that they are optimized for electronic transmission, making them a common file for picture sharing. They are universally readable by editing software and picture-processing programs.

The amount of compression is often given a label that defines its quality, such as Extra Fine, Fine, and Standard; or High, Standard, and Basic. JPEG files that are saved with the least compression will look very good. But as the data is compressed into smaller (Fine, Standard, etc.) and even smaller (Standard or Basic, etc.) files, degradation in the form of line-edge softness or blotches in large areas of smooth color will be visible. These problems may not be noticeable in small prints, but for situations that call for your finest photos, stick to the highest quality, least compressed files. I generally shoot JPEGs at the highest quality (least compression) unless the lighting situation is problematic and I know that the image is going to require a lot of surgery in the computer using my image-processing program, in which case I may decide to shoot RAW files.

RAW

A RAW file (raw as in pure data) is made up of the uncompressed, unprocessed image data coming from the camera sensor. Most D-SLR and many EVF cameras have the option of providing digital images as RAW data.

RAW files are the best choice for critical applications such as images for publication, for making large prints, and for shooting pictures in difficult lighting situations where a lot of post-exposure editing and image repair will need to be done with processing software in the computer.

Rick Ott, artist

RAW format offers unprocessed information from the sensor, giving greater flexibility than JPEG to process image attributes such as exposure, contrast, hue, white balance, and sharpening in the computer without affecting the original data.

Every camera maker has a proprietary version of RAW (each with their own file extension). There's a Nikon RAW (.NEF), Canon RAW (.CRW or .CR2), Olympus RAW (.ORF), etc., and these files are different from each other. Adobe and other makers of image-processing software offer RAW processors in their programs. If you want to shoot RAW files, make sure your image-processing software can read those files.

RAW files are big because they contain so much data, which means they are usually buffered when waiting to be written to memory cards. With some cameras, this can take a long time. Some cameras will even lock-up during the writing, preventing further picture taking. Large files also mean that fewer images can be saved to a memory card.

TIFF

TIFF (Tagged Image File Format, abbreviated as the extension .tif) is a non-compression format. Like RAW, the files are large. This format is not found on as many cameras as JPEG and RAW, but it is the file format found on many film scanners and offered for saving files in image processing programs. RAW or JPEG files imported into a computer image-processing program should be saved as TIFFs after processing. TIFF is a good choice to store images for publication and for archiving images.

HIGH RESOLUTION FILES FOR PUBLICATION

Depending on the number of pixels used by your sensor to record a file, your photo has a set number of pixels across its width and height. By using image-processing software, your computer can spread these pixels or pack them closely. This means you can change the image resolution–the number of pixels per inch (ppi) in your picture. Spreading the pixels will make the photo bigger, but it will blur the details (less data per inch). Packing the pixels more densely creates a smaller but sharper picture. An image resolution of 300 ppi is considered high enough to insure good, detailed prints and publication images.

When submitting a picture for publication, it's good to know the actual size your photo will appear in print. If the picture is to print at 4 x 5 inches (10.2 x 12.7 cm), set your image resolution in the Image Size/Resize portion of your software for 300 ppi and the image size at 4 x 5 inches. This gives you a picture that is 1200 x 1500 pixels (4 x 300 + 5 x 300), or a total area resolution of 1.8 megapixels. If the printed photo is meant to completely fill an 8 x 10 inch (20.3 x 25.4) page, you must set the image resolution again for 300 ppi, and set the image size at 8 x 10 inches (if the file size allows). Now the picture is 2400 x 3000 pixels, or 7.2 megapixels.

Art directors at magazines and ad firms ask for image files that are as large as possible. Such high resolution gives them the latitude to fill a large image area at 300 ppi, or crop the file in order to meet smaller space specifications. For most publications, either a RAW, TIFF or large size/low compression JPEG file is required. Professional photographers who shoot for publication usually use digital cameras with a sensor resolution of 8MP or higher, because their image files will be large enough for most magazine requirements.

Keep in mind that smaller files can be used for publication, they just can't be printed as large. If you only shoot for publication on rare occasions, then a digital camera with a resolution of 5 or 6 megapixels will meet most of your needs.

Today's digital cameras have an iris diaphragm in the lens that can be adjusted to control the amount of light passing through it.

Exposure

The term exposure refers to the process of light striking a sensitized medium, creating an image. (With digital cameras, this image data is processed to some degree and saved to a storage medium.) Digital cameras control exposure using three variables: the lens opening (f/stop or aperture), the shutter speed, and the ISO (signal amplification or gain). Too much light and the image will lack highlight detail and appear washed out. Too little light causes dark areas to block up and not show detail.

Digital cameras have built-in exposure meters that measure light and compute a recommended exposure based on these readings. Depending on the camera, the meter may use different metering patterns such as multi-segment, center-weighted, and partial or spot. Some meters are also programmed to bias their reading for the autofocus area in use and to adjust for conditions such as back lighting. All of these methods aim to give the best exposure recommendation possible. However, some subjects of unusual reflectance or some scenic conditions can fool the meter. In these cases, you may want to switch to Manual exposure mode or try exposure bracketing.

The Aperture

The aperture is an adjustable opening in the lens that controls the amount of light passing through it to reach a digital camera's sensor. The size of this opening is known as the f/stop: the larger the opening, the smaller the f/number; the smaller the opening, the larger the f/number. The f/numbers in photography are standardized: f/1.4, f/2, f/2.8, f/4, f/5.6, f/8, f/11, f/16, f/22, and f/32. Each of these f/stops has a 2:1 relationship to its neighbors. This means that an aperture of f/8 is half the size of f/5.6 but twice as large as an aperture of f/11.

I'll use the term "opening up" to mean resetting the aperture so it allows more light to reach the sensor (smaller f/numbers, going from f/8 to f/4, for example). When I say "stopping down," I mean reducing the size of the aperture to cut back on the amount of light reaching the sensor (going from f/5.6 to f/11, as an example).

an overview of digital photography

The depth of field is shallow with only the closest wires in sharpest focus. This helps to separate them from the other parts of the basket, allowing the detail of the craftsmanship to stand out against the softer background. If a small aperture such as f/11 or f/16 had been set, much more of the basket would have been equally sharp, and the overlapping wires would have been less distinct from each other.

Depth of Field: Depth of field is the distance in front of and behind the plane of focus in your scene that is acceptably sharp in your photo. One factor that affects depth of field is the size of your aperture. As the f/numbers get larger and the size of the aperture is reduced (going from f/8 to f/16, for instance), the depth of field increases. When photographing objects, we often want as much depth of field as possible, meaning we want to stop down, using the smallest aperture available.

Note: Most lenses are described by a combination of their focal length and their widest aperture setting. A lens that is identified as a 50mm f/2.0 means it has a focal length of 50mm (moderate telephoto on a D-SLR) with a maximum (widest) aperture of 2.0. Similarly, a zoom lens described as 35-105mm f/2.8-8 can be set for focal lengths between 35 and 105 mm, with a maximum aperture that will vary between f/2.8 (wide end) and f/8 (telephoto end) according to focal length.

Shutter Speed

The shutter speed is the other factor used to make an exposure. It controls the length of time the light strikes the sensor. Most shutter speeds are a fraction of a second. For example, 1/60 means the shutter is open for 1/60 of a second. When you press the shutter release, the shutter opens for a precisely set duration. Like aperture settings, shutter speeds are standardized: 1/1000, 1/500, 1/250, 1/125, 1/60, 1/30, 1/15, 1/8, 1/4, 1/2 and 1. And just like aperture settings, these are in a 2:1 relationship with each other—and each full change represents a one stop adjustment in exposure. Today's cameras often use infinitely variable shutter speeds, but we refer to them in terms of standard speeds.

Shutter speeds are important for sharpness and clarity of your photographs. The faster the shutter speed, the less likely that pictures will be blurred by camera shake. With a normal lens, using a shutter speed faster than 1/60 second allows most of us to take sharp pictures handholding a camera. Shutter speed is also used to stop motion. A high shutter speed allows you to capture a diver in mid-air or a baseball about to be caught.

Metering Modes

Digital cameras offer different ways of calculating the correct exposure, and you can choose which one works best for a specific shooting situation. There are three basic methods to measure light exposure found on most digital cameras. They are multi-segment (sometimes call honeycomb or matrix metering), center-weighted, and spot metering.

Multi-Segment Metering: In the multi-segment mode, the image frame is divided into a number of different areas that the meter measures. The camera's processor analyzes the data and compares it to stored image data to make the final exposure determination. This "intelligent" system produces very good exposures for most ordinary photography, but when photographing objects with complex lighting or large areas of uniform color, it may not be reliable.

Center-Weighted Metering: Center-weighted systems read the entire frame but weight the measurement of the central area more heavily in determining exposure. Some cameras weight the lower-central area when the camera is in the horizontal position, while others just weight a central area.

Spot Metering: The third choice is spot metering, which is very useful for object photography. The exposure reading is taken from a small area in the middle of the frame, usually coinciding with the focus patch area. To use the spot meter, move the metering area over the object (or an important area of it) and get an exposure reading by pressing the shutter release halfway. Maintain pressure and reframe the image, then continue to depress the shutter release to take the photo.

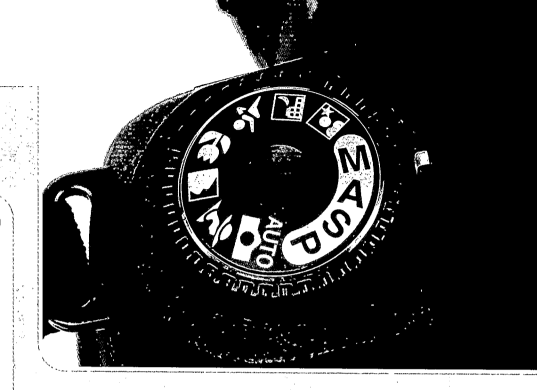

Exposure Modes

The Mode dial on most digital cameras looks like the shutter speed dial found on traditional film cameras. It usually sits on top of the camera's body and is used to select the method the camera will use to expose the scene. The letters P, A (or Av), S (or Tv) and M, along with AUTO, can usually be found on the Mode dial.

AUTO: In AUTO, the camera controls all settings and usually allows no variations.

Program Mode (P): In P mode, the camera selects a combination of aperture and shutter speed based on its meter reading and other stored data. However, this mode usually permits you to use exposure compensation if needed, plus it often allows you to shift one aspect of the aperture/shutter speed combination and the camera will compensate by adjusting the other.

Aperture Priority Mode (A or Av): In this mode, the photographer selects the aperture and the camera chooses a shutter speed that will correctly expose the scene. This is useful for close-up and 3-D object photography because it allows you to set small apertures (f/11 or f/16) in order to assure maximum depth of field and overall sharpness.

Shutter Priority Mode (S or Tv): In this mode the photographer sets the shutter speed and the camera selects the aperture for proper exposure. Shutter priority mode is often used to control the exposure of moving subjects. Since antiques and craft objects aren't usually moving around a lot, we are more concerned with controlling the aperture for sufficient depth of field than selecting a shutter speed to stop motion.

Manual Mode (M): The photographer chooses both the shutter and aperture settings. For me, this is absolutely the most useful exposure mode for object photography. It gives me total control over exposure, and I shoot in M mode most of the time.

You may see additional icons on your camera like a face, a mountain, or a flower on the Mode dial. They are factory settings created to optimize photos for specific situations like shooting a portrait, a mountain scene, or a flower. These aren't of much use for object photography.

ISO

One critical exposure control is ISO (International Standards Organization). This is a standard measure of the camera's sensitivity to light and is important for creating good images. The higher the ISO setting, the higher the sensitivity to light (and the less light you need for photographs). The ISO in digital cameras is adjusted by amplifying data from the image sensor within the A/D converter. Most cameras offer several ISO settings: 100, 200, 400, or higher. Amplification of the signal using higher ISO speeds often results in noise (a speckling or grainy effect in areas of the image). I advise to shoot pictures at the lowest ISO setting possible –usually ISO 100 or 200 depending upon the camera. It is best not to use higher sensitivity for the photography of objects.

Focusing Systems

All digital cameras have an autofocus feature. Looking in the camera viewfinder, you will see markings that indicate the location of the focusing sensor or sensors. With simple systems, this is most often a spot in the center of the frame; more complex systems have multiple focus points. Place the AF sensor you want to use on your subject, press the shutter release halfway, and the autofocus will determine the distance to the subject and move the lens to get the sharpest image. Some autofocus systems move the lens until the subject shows the highest contrast, while other systems use infrared beams to measure the distance to the subject. In most situations, these systems work rapidly and accurately, having come a long way in the two decades since they were first introduced on film cameras.

The best argument for autofocus is that the viewfinders on most digital cameras are difficult to use for accurate manual focusing. Point-and-shoot cameras don't provide any focusing information in their small viewfinders or their LCDs, while the electronic viewfinder screens on EVF cameras can be too coarse for critical focusing. The viewfinders on D-SLRs are better, though on some models they may be smaller than those on comparably sized film cameras.

Autofocus systems don't always work well in low light. In your house or in a studio, the lighting is much lower than outdoors–too low for many autofocus systems. Photographing objects with large areas of uniform color or tone often throws off autofocus systems, which can occur with subjects as varied as large modern paintings to small silver bracelets.

Sometimes when there isn't enough light, there are no contrasting elements in your subject, or the subject is too close, the autofocus system will hunt for focus indefinitely. I choose to turn off the autofocus when working in the studio, preferring to use manual focus. On some cameras this is easy to do. Often there is a control in the menu or on the camera body that switches between autofocus and manual control. If you are shopping for a digital camera, particularly one that is not a D-SLR, it is a good idea to look at models that allow you to set focus manually.

White Balance (WB)

If you are shooting file types other than RAW, you must tell the camera how you want it to set the white balance. (With RAW, this can be done when the file is processed in the computer, but it is still best to set white balance as accurately as possible in the camera.) White balance sets the camera for the color temperature of the light falling on the subject so that it will reproduce subject colors correctly. (For more on white balance, see pages 41-42.) Most cameras offer several methods for setting white balance (see the owner's manual for specific instructions for setting white balance on your camera).

Auto White Balance (AWB)

The camera determines the white balance setting. This works well for snapshots in fairly standard lighting conditions. It is not recommended for photographing art or craftwork because colors may not be rendered faithfully.

Fixed Settings

Many cameras offer the option of selecting a specific lighting type or condition. This may or may not work well depending on subject or lighting conditions. These include:

○ Household (tungsten/incandescent) lighting (often designated by a light bulb icon).

○ Fluorescent lighting (often designated by a horizontal bar with light rays).

○ Flash (often designated by a lightning bolt icon).

○ Outdoors on a sunny day (often designated by a sun icon).

○ Outdoors on an overcast day (often designated by a cloud icon).

○ Outdoors in shade (often designated by an icon of a small house with an overhanging roof).

Kelvin Temperature (K)

Some cameras allow you to set the Kelvin temperature from a reading made with a color temperature meter. Others allow you to set a Kelvin temperature range. Some sophisticated pro cameras also allow you to fine tune the red-blue or magenta-green balance in addition to other options.

Manual

Some camera manufacturers call this method Custom or Preset. Often considered the most reliable way of getting accurate color in an image, Manual white balance is performed by taking a reading or picture with the camera of the lighting in the scene reflected off a white or neutral gray card. (You should make sure the lighting on the card is identical to the lighting on the subject for an accurate measurement.) The camera uses this information to set the white balance for the actual light in the scene. For more on this technique, refer to the owner's manual or the *Magic Lantern Guide* for your camera.

White Balance with RAW Files

The RAW format allows you to set white balance later in the computer, and because of this some photographers believe that you don't need to fool with white balance at the shooting stage. Some other photographers just set Auto white balance and expect to tweak the RAW file during processing. However, these approaches can create consistency and workflow issues.

Setting white balance before shooting is the best choice because when you process the RAW files, the settings that you chose will come up. Tweaking the white balance at the image-processing stage rather than starting from scratch with major corrections will probably give you the best results. There will be times when getting correct color is difficult, and the RAW software white balance correction may be a big help.

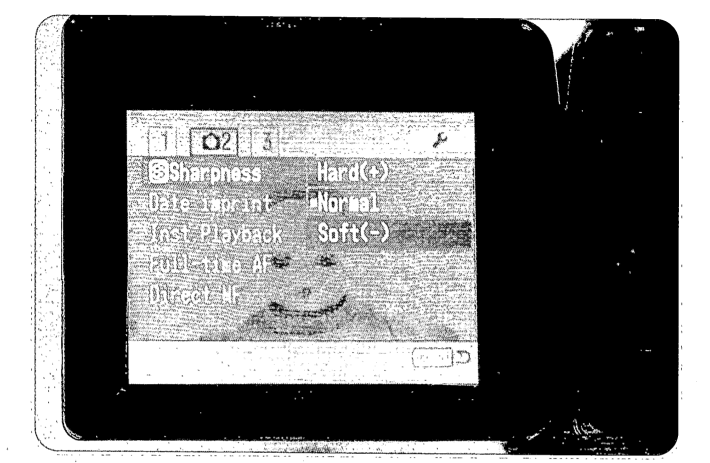

Color

Many digital cameras have a color setting that lets you choose how color is rendered in the image file. Common settings are Vivid, Natural, sRGB, Adobe RGB, and perhaps Portrait. What are the differences? This setting manages how saturated the colors are, whether flesh tones are emphasized, and so on. sRGB (called Natural on some cameras) or Adobe RGB (if you are going to edit the photo in Photoshop) are the settings to use for the most accurate color rendition.

Sharpness

Sharpness is an interesting word in digital photography because it refers to a few different things. There's optical sharpness, which deals with lens resolution; depth of field, or the area of acceptable sharpness within a scene; focus; and file sharpness, having to do with the level of contrast between adjacent pixels in your image file. Most cameras allow you to modify the file sharpness through a setting that is generally found on one of the menu pages. Selection choices may be numerical (e.g. -3 to +3) or descriptive, (hard, normal, and soft). In many cases, you may choose to do this in the computer, where you have much more control.

Choosing the Right Camera

There are hundreds of digital cameras on the market with new models appearing all the time. Finding the right camera can be confusing. To start your search for a digital camera, carefully consider what you want to do with it. Will you only need a camera for web shots? Do you need to get very close to small subjects like stamps and coins? These questions will help you determine which of the three camera types meets your needs and best fits your budget. Then look at several websites or magazines that sell or review digital cameras (such as PCPhoto magazine) and research the type in which you are interested. Compare their capabilities and read the reviews.

Once you find a camera that seems to fit your needs, go to a camera store and handle it. Many digital cameras are surprisingly small and you want to see how comfortable the camera feels in your hands. Are the controls conveniently laid out? How easy is it to focus and frame pictures? Are the setting options easy to locate? I find it important to be able to change camera settings and access menus without difficulty. I hate having to go through half a dozen menu pages to turn something on or off. Also, play with the viewfinder system. Ask yourself how well it works for you.

In particular, I want to be able to turn off the camera's automatic features, like autoexposure and autofocus, so I can set the camera for manual operation. If you want to do this, determine if this is simple to do on the camera you are considering.

If you shoot small objects, such as earrings, check the camera's minimum focusing distance specifications. You can also bring some objects to the store and see if the camera can easily be focused close enough for them to fill the frame. In some stores you can actually shoot a frame and get a print made. I've done this and, to my surprise, discovered that some cameras did not focus as sharply as they were supposed to at close range.

• Handle the controls. Are they clearly marked and easy to operate? Go into the camera's menu system. Is it easy to access and set options like white balance, image size, and image quality? It should be. Setting apertures and shutter speeds should be straightforward and not hidden on a third- or fourth-level menu page. If a camera is difficult to use in the store, it will be impossible to use in the real world.

• Look for a grid screen. Many digital cameras have a grid feature in the LCD. If you are photographing things that are rectangular, like paintings, a grid screen is a major asset.

For most object photography it will be advantageous to use a camera with a resolution 5 MP or higher. Unless you want to print a lot of extremely big photos, or extensively crop your images, you probably won't ever need more than an 8 MP sensor in your camera. An EVF camera in this range may be your best buy, especially if you aren't planning to purchase lots of extra lenses.

While there are several D-SLRs bodies that cost about the same as higher-end EVF cameras, you should also factor the extra expense of buying a lens for the D-SLR. Some bodies are sold with midrange zoom lenses that are good for general photography but often do not focus closer than one or two feet (.31 – .61 meters) from a subject—not nearly close enough to photograph a number of art or craft objects. The permanent zoom lenses on EVF cameras often have longer focal-length ranges and better close-up capability then these interchangeable lenses that come packaged with the purchase of a D-SLR body.

If you decide to get a D-SLR, look at the lenses available for it. The versatility of the D-SLR is based on the different lenses that are compatible with the camera's body. But wide angle, macro, and extreme telephoto lenses for D-SLRs can become costly very quickly. These lenses are superb optical instruments, but you have to ask yourself if you really need that level of quality. It can be very difficult to distinguish the difference between images taken with a point and shoot, EVF camera, or D-SLR when viewed on a computer screen or in a 4 x 6 inch (10.2 x 15.2 cm) or smaller print.

If you already own a Nikon, Canon, or other SLR film camera system, you may be able to use some of your older lenses on a digital camera. This may seem to be a selling point for a new D-SLR, but remember that a film lens on a digital body gives a cropped field of view. That favorite 24mm super wide-angle lens you used on your film camera will not give the same wide view on a D-SLR (unless the sensor is the same size as a 35mm film frame). As a matter of interest, digital lenses do not work on film cameras because the circle of light they project is too small to cover the film frame.

Smart Buying

The online marketplace is a huge floating bazaar where the price of everything is as variable as the weather. The prices of digital cameras at your local camera shop may be a little higher than with online sellers, but having a relationship with the store is usually helpful. If something goes wrong with the camera, you can get it exchanged or fixed more easily. More importantly, if you have questions about the camera, you can get face to face answers and live demonstrations to show how something works. If you encounter a difficult technical problem, the people at the shop are usually happy to hunker down and try to resolve it. This added service at your local camera shop can be invaluable.

With a selection of lenses to suit nearly any photographic situation, a D-SLR offers more versatility than other camera types. But research your photography needs to determine whether you really need to make the substantial investment required for a camera body plus multiple lenses.

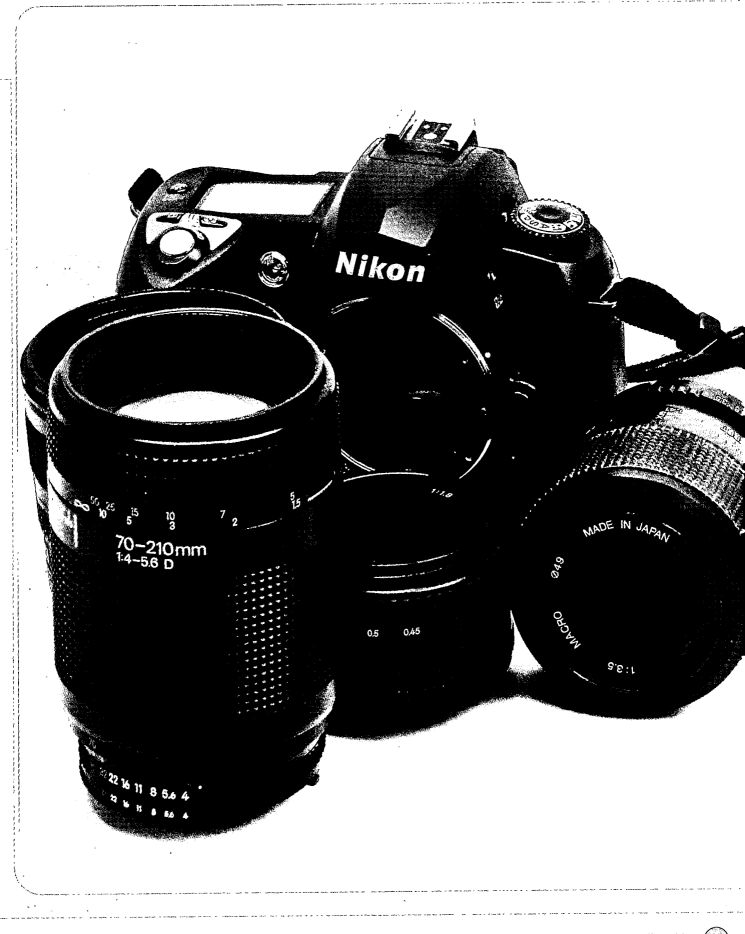

light and
the digital studio

The poet Wallace Stevens has a great line in his poem entitled The Glass of Water: "Light is the lion that comes down to drink." In photography, light certainly is the lion. It is an essential component for making pictures. Even the word, photography, means writing with light. Thus, to take the best pictures possible, it is essential to learn a little about the nature of light and how to use it to enhance the objects in the photograph.

The Fundamentals of Light

L et's take a very quick look at the fundamentals of light and how to apply these principles when shooting art and other objects. You may recall from high school physics, visible light is a type of electromagnetic radiation (other types include radio waves, infrared, and x-rays). What we see as colors are really different wavelengths of this energy. The primary colors of light are the three fundamental wavelengths that we perceive as red, green, and blue (RGB). Additional colors are formed by a combining of these in different proportions.

These photos demonstrate different color temperatures of light. The light emitted by a tungsten household lamp (above) is warm, with a rosy color cast. The picture below has been corrected using the camera's white balance control set to tungsten (light bulb icon). Note the cooler blue background and the whiter whites in the cord, base, and stem of the light.

Color Temperature

As we look around in everyday life, we aren't normally aware that light has different color casts or color temperature. The light from a rising sun has a different wavelength (and is redder) than the light found in shade under a tree. And the light from a household light bulb has different wavelengths (and therefore casts a different color) than either. Our brain subjectively adjusts our perception of these differences so we don't see them. But a camera objectively records the color cast of the scene.

The range of color in light can be measured as color temperature, expressed as numbers on the Kelvin (K) scale. Any light source, depending on its proportions of red, green, and blue, has a dominant color and a specific temperature. If the light consists of equal amounts of RGB, it is called white light and appears neutral. Light with more red in it (like the sunrise) has a warmer value (lower Kelvin temperature). Bluer light, like a cloudless sky on a clear day, is perceived as cooler and has a higher Kelvin temperature.

This becomes important to photographers because light with a particular temperature can introduce a color cast, or over-all discoloration, into the picture if it doesn't match the white balance setting you are using. A white background or wall will look white with no color cast when a neutral light shines on it, but will have a yellow tone when lit by a warm light, or a blue cast when lit by a cooler source.

To record color as our brain interprets it, the camera has to compensate for the actual color temperature of the light . (In film photography, this is done with filters or by selecting a film with an emulsion that is matched to a certain type of lighting). With a digital camera, this compensation can be performed with a control known as white balance, which adjusts the image processor to make a white object neutral, without the color cast emitted by the light.

White balance on your digital camera can only be set for one distinct light source at a time. When a scene includes light sources of different temperatures, there can be color casts recorded in the picture that even image-processing software will have difficulty correcting. Color casts are common when shooting indoors in a room lit by tungsten lamps (yellowish lights) and window light (bluish daylight). They can also occur with fluorescent-lit rooms because there are several types of fluorescent lights that have different color temperatures. These different fluorescent lights are often randomly mixed in fixtures so that locations such offices, galleries, stores, and public places are a combination of color temperatures. One way to deal with evenly mixed lighting is to set the white balance manually (if your camera has this capabili-

Kelvin Temperature Scale

Source	Approximate K
Candle flame	1800
Sunrise/sunset	2000
40-watt incandescent bulb	2800
Tungsten studio floodlight	3400
Summer daylight at noon	5500
Overcast sky	6000
Summer shade	7200

ty) by taking a reading off a white or neutral gray card. Some camera manufacturers call this function "Custom" while others call it "Preset." This setting balances for the actual color temperature in the scene. Check your camera's own-ers' manual, or refer to the *Magic Lantern Guides* series of advanced user guides, for complete instructions on how to perform this function.

Direction

Light has direction. Normally we experience light as coming from overhead sources like the sun or ceiling lights. Some exceptions are sunset, when light can be almost horizontal, and an overcast day, when the light seems to have no direction at all.

In photography, the direction of the light is named according to where the source is placed in relation to the subject. Put a light in front of a subject and you have a front light. Put it behind the subject and it is a back light. Consequently, side light is when the source is on either side of the subject.

Controlling the direction of the light in a photograph is important because it both makes the picture look normal and it defines texture. The direction of light along the horizontal plane defines texture and shape. A front light produces a very flat image, lacking in texture. As the light is moved to either side of the subject, textural qualities increase. Object texture becomes evident when the light is about 30° or more from the front. As the light source moves around the subject, the shadows become longer and deeper and the texture more prominent.

The direction of light in the vertical plane is important too. Normally light comes from overhead sources, and we take most photographs with overhead or angled lighting. Having the light come from below the subject is used in only a few situations, primarily with glass and some translucent materials.

When light comes from directly in front of the subject, shadows are reduced and surface texture is flattened (above). Moving the light to one side or the other increases shadows and makes the subject's textural qualities more visible (below).

Quality

Consider the quality of light as a continuum from hard to soft. A bare light bulb produces a hard light. It is strongly directional producing distinct, sharp-edged shadows. This is called specular light and is recognizable by its high contrast and harshness. The opposite of specular is diffuse light. Rather than coming from a single point, diffuse light seems to come from everywhere. Shadows, if any, are soft and faint. Like the light on an overcast day, diffuse light is flat with little contrast.

In photographing objects, the trick is to match the quality of the light to the surface and material of the subject. It's a yin and yang balance: Hard balances soft; soft balances hard. The reason to seek the balance between light quality and surface is to avoid overexposed or washed out areas. These areas look blank and contain no digital image information. Processing programs can often lighten dark areas, and even have fill-flash tools designed to bring out detail in black areas. But burnt-out areas are gone and can't be retrieved by processing software. This makes it important to control glare and ensure that all of the subject's contrast is within the latitude range the camera can record. The histogram is a feature found on most digital cameras that shows the distribution of tones in your image, and can quickly illustrate whether you have exceeded the limits of your camera's ability to record detail in dark or bright areas of the picture (see opposite page).

Soft Surfaces and Hard Light

Daylight on a sunny day is mostly specular sunlight and the shadows are distinct. It's light that you can use to photograph soft subjects like natural fabrics. These soft subjects do not have much contrast, but the hard light can create shadows and depth.

Hard Surfaces and Soft Light

Hard subjects are usually just that, hard. Things like silver, gold, glass, or anything that has a polished surface and a lot of glare. Here, a hard source of light like the sun or a light bulb is simply reflected by the hard surface as a bright spot of glare. A softer light will balance the hard surface. That's why ads for shiny automobiles are invariably shot on cloudy days.

Most objects are neither totally hard nor totally soft, and few light sources are purely diffused or specular. Almost everything falls between the extremes, and the trick for making good photographs is to figure out the right lighting for each object. There are all sorts of devices to modify and control the quality of light.

Quantity

The final component of light is quantity: How much light is there? From the intense sunlight on a beach to the light of a single candle, we need to know how much light there is for taking pictures.

In the early days of photography, whole books were written consisting of tables that gave the exposure for light intensity, thus telling the settings to use for different times of the day, in different weather conditions, and different latitudes around the world.

Luckily it is no longer necessary to keep such charts and tables handy because today's light meters can accurately measure the amount of light in a scene. Your meter can now tell which aperture and shutter speed settings to use so that just the right amount of light falls on the sensor.

THE HISTOGRAM

This is a feature found in most digital cameras that lets you review the range of tones of a recorded image on the LCD monitor. It is a graphical display with a horizontal and vertical axis. The horizontal axis represents tonal values from dark (on the left side of the graph) to bright (right side of graph). The vertical axis shows how many pixels have a specific brightness value. As you look at a histogram, you typically see a profile that looks like hills and valleys, starting at the bottom of the left (dark) side, rising one or more times toward the center, and descending in a slope to end at the right endpoint. If the graph hits either left or right side in an abrupt, cliff-like vertical drop, detail will not be seen in dark or highlight areas. Dark areas will be blocked up and highlights will be washed out.

This histogram shows an image that lacks the darkest tones (graph ends before reaching the left axis) but is well exposed for highlights, with the right-hand side of the graph sloping to end just at the right axis. This image will probably not have much detail in deep shadows, but should contain texture in the bright areas. Photo © Simon Stafford.

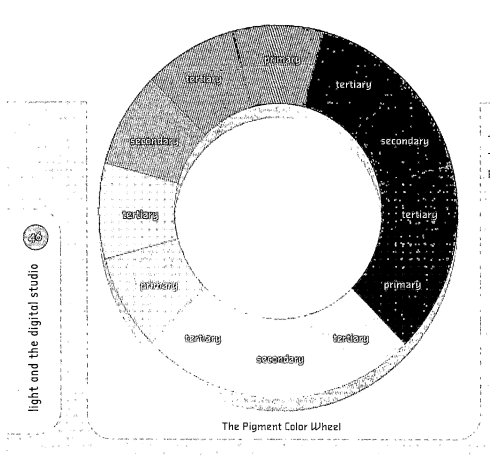

The Pigment Color Wheel

Taken from Designer's Color Manual by
Tom Fraser & Adam Banks. © The Ilex
Press Ltd.

A Bit of Color Theory

Color is an important tool to make a strong image. However, colors in the background can often work against the crucial colors in the object, weakening the whole image. It is useful to understand how colors affect each other.

The color wheel above illustrates the way pigment colors relate and interact. From their positions on the wheel, we describe the colors and their interactions as:

1. First order colors, or the primaries: red, yellow, blue. These three cannot be produced from any other color combinations.

2. Second order, or the secondary colors: orange, violet, green. They are made by combining the three first order colors.

3. Third order, or tertiary colors, are made by mixing a primary with a secondary adjacent to it in the color wheel. This produces colors like yellow-green or blue-violet, etc.

4. Black, gray, and white are not on the wheel. White is the absence of color, black is the combination of all colors, and gray is formed when opposite colors on the wheel are mixed.

5. Colors that are opposite each other on the color wheel are called complementary colors. Used together, they produce maximum color contrast and harmony. The main complementary pairs are red/green, yellow/violet, and blue/orange.

Simultaneous Contrast

Terms like saturated, unsaturated, pure, degraded, or hue-less are used to describe the purity and intensity of a color. A pure color is one at its maximum saturation and without any other color mixed with it. A color that is washed out (white's been added) or unsaturated, or is degraded because of contamination by other colors, is called impure.

When a large area of impure color is placed next to a pure color, the pure color appears weakened. For example, a bright red ball placed against a pale green background will lose its rich redness. This effect is called simultaneous contrast. It is the reason that photographing anything with a solid gray background is a bad idea. The gray sucks the color out of your work; it makes the pictures go lifeless.

Color Contrast

The contrast between adjacent colors in a scene contributes to the sense of dimensionality in a photograph. Lighter and warmer colors come forward. They can seem to jump out of the frame. Darker colors and cooler colors recede into the frame. Here are a few examples of how color contrast can affect an image:

Figure 1. White expands, black recedes. The white rectangle appears to jump off the black frame, creating a 3-D effect. When you have a black object on a white or light background, the object appears to fall into the frame away from the viewer.

Figure 2. Here a saturated color stands out on the black background.

figure 1

figure 2

figure 3a

figure 3b

figure 4

Figure 3a. The blue is luminescent on black, but notice how it seems to recede into the black.

Figure 3b. Against a gray background the blue loses its intensity.

Figure 4. Now look at what happens when an area of color is added to Figure 3a. A yellow rectangle is placed on the blue, its complement. The effect is startling. The yellow dominates both the blue and the black colors. It jumps forward to draw our attention to it.

These illustrations demonstrate the powerful effect colors have on each other. You should be aware of the relationships and interactions between colors when photographing objects.

The ways in which colors affect each other and how they produce their emotive effects is a huge topic that is largely intuitive. The French artist Henri Matisse spent decades meticulously exploring color relationships, painting and repainting canvases until they produced exactly the feelings and sensations he wanted. One of the best ways for a photographer to improve his or her understanding of color is to study great paintings to see how the colors are used by the artist.

The Basic Studio

Studios come in all sizes and shapes, from a huge warehouse for photographing such things as minivans, to a small table top for jewelry pictures. The most important reason to create a shooting space for the photography of objects is to have control. A studio space allows you to both control lighting and to produce consistent, repeatable results.

The key to a studio space is to have enough room for objects, lights, and camera. Lights and camera need to be moved around to accommodate different subjects, which also may need to be moved around as well. Always try to find a space large enough to accommodate this movement rather than one that just fits your equipment.

For most photography of normal sized objects—anything smaller than a bicycle—a space that is at least 10 x 10 feet (3.05 x 3.05 meters) will work. For smaller things like jewelry, dolls, and old toys, a tabletop space that's 4 x 6 feet (1.22 x 1.83 meters) is all you need. When it comes to photographing large subjects—models, quilts, furniture, etc.—you'll need a larger space. I use a room with high ceilings and at least 15 x 20 feet (4.56 x 6.1 meters) of floor space.

How Much Equipment?

Here is a list of the minimal amount of equipment for the photography of art, craftwork, collectibles, and other objects.

1. A digital camera and a zoom lens with focal lengths from moderate wide angle to moderate telephoto.

2. A memory card.

3. A tripod.

4. A background. This can be a large piece of neutral colored paper, a long roll of photo background paper, or a large piece of tight weave fabric.

5. Miscellaneous items like paper and pencil, a tape measure.

6. Lighting. One or more lights: tungsten, halogen, or electronic strobe with light stands.

7. Light modifiers. Umbrellas, reflectors, light boxes, or softboxes.

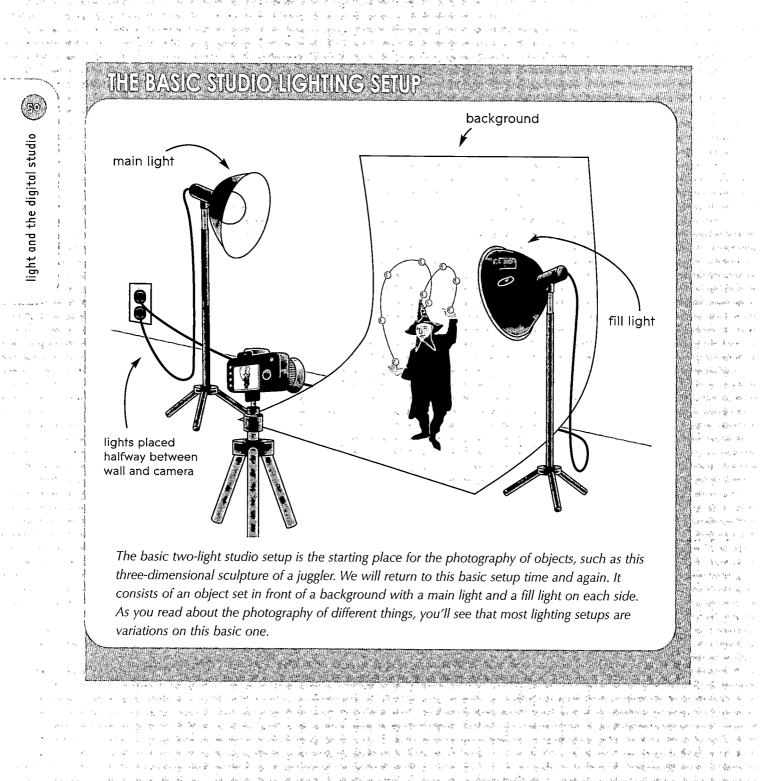

THE BASIC STUDIO LIGHTING SETUP

background

main light

fill light

lights placed
halfway between
wall and camera

The basic two-light studio setup is the starting place for the photography of objects, such as this three-dimensional sculpture of a juggler. We will return to this basic setup time and again. It consists of an object set in front of a background with a main light and a fill light on each side. As you read about the photography of different things, you'll see that most lighting setups are variations on this basic one.

Lighting in the Studio

We need light to make photographs. Some sources of light are more reliable and consistent than others. Let's look at the different types of light and how useful each is.

Daylight

Natural light is cheap, abundant, and is the first source everyone uses when they originally get into photography. It's not the best light for object photography because it is not as easily controlled as artificial light, but it is possible to shoot decent photographs of objects in daylight.

The color and angle of light from the sun varies throughout the day and is different in different weather conditions. Morning light can be rosy warm; evening light may be yellow-reddish. The quality of light on a sunny day is harsh with very bright highlights and deep blue shadows, while on overcast days it is soft and cold white.

This variability of daylight from one time period to the next is the main control problem with the photography of objects outdoors. For some photography, where color isn't a critical issue, or when the subject is not a difficult one to shoot (no shiny surface for example), daylight will do the job.

Look at the sketch of the basic studio on the opposite page. If you are using natural light instead of studio lighting, think of the sun as the main light and modify the setup accordingly. For the second, or fill light, you can use a white reflector or daylight-balanced, electronic flash.

THE INVERSE SQUARE LAW—WHY IT HELPS TO KNOW ABOUT IT!

Any photographer who works with flash and lighting has witnessed the situation that occurs when you move a light away from a subject–the light on the subject becomes less bright. The reason for this is explained by the Inverse Square Law, which states, "Illumination from a light source is inversely proportional to the square of the distance from the source." Thus, light is reduced, or diffused, as it travels away from its source.

As a formula, the Inverse Square Law is stated:
Light intensity = $1/Distance^2$

Practically, this means, if you double the distance between the light source and the subject, the light source must emit four times as much light to maintain the same level of subject illumination.

Distance makes a big difference:

Distance:	1x	2x	3x	4x	5x
Quantity of light:	1	1/4	1/9	1/16	1/25

Tungsten Lights

Tungsten lights include sources like household light bulbs, large floodlights, and high-intensity quartz-halogen lights, to name a few. In all of these, electric energy passes through a wire in a vacuum or gas-filled environment where it is turned into heat and light. The more energy the wire can turn into light, the brighter the lamp. The light from these lamps has a color temperature in the 2800K to 3400K range. This is a yellow-red light, which we see when we look at the lights in a home at dusk. These are called continuous lights because they are constantly on, allowing the photographer to see how the light is falling on the subject.

There are two main types of tungsten photo lights. One is composed of lamps that look like big light bulbs (which they are) and come in 250-, 500- and 1000-watt output. Like ordinary house lamps, they screw into lamp-socket fixtures that are usually mounted in some sort of reflector housing. The other type of tungsten light uses quartz-halogen lamps. These lamps are small and usually have prongs that plug into the lamp housing. They are hotter, brighter, more color stable, more expensive, and longer-lived than similar wattage bulb lights. Both types of tungsten lights are simple to use and less costly than electronic studio flash.

These lights are also called "hot lights" for good reason. The glowing tungsten filament generates not only light, but a lot of heat as well. Quartz lights are even hotter than bulb lamps. All hot lights need to be used with the greatest caution. Handle them with care and never touch metal surfaces heated by the lights—things like reflectors and stands. Keep them from touching flammable materials like the nylon material of studio umbrellas, softboxes, and light tents, because they will quickly melt these substances.

Tungsten lights can be used in various sizes of reflector housings. Usually these half-dome aluminum reflectors are between 8 – 12 inches (20.3 – 25.4 cm) in diameter. They increase the effective amount of light from the lamp by

Light stands are useful to securely support lighting. They allow the photographer to place the lights at different heights and positions around the subject.

bouncing more of it towards the subject. When a lamp is used in wide reflector housing, the light is considered a floodlight. If the bulb is in a narrow reflector or some kind of focusing housing, it is considered a spotlight.

You can buy inexpensive reflector housings mounted on a clamp. To use these clamp lights, you need something like a ladder or shelf to attach them to, which can make things a bit awkward. A better solution is to get reflectors with light stands. Stands are collapsible, adjustable, and available in several price ranges. They allow you to control the placement of the lights.

Tungsten lights are often sold in kits that include two lamps with reflector housings, light stands, and a pair of photo umbrellas. These kits are designed to be used with either tungsten floodlights or quartz-halogen lamps and are sold by most larger photographic supply houses.

Do take caution when you use one of these kits because there is the chance of overloading household electric circuits. Using two 250- or 500-watt lamps on the same electric circuit that serves other household appliances and lights can easily blow your circuit breakers.

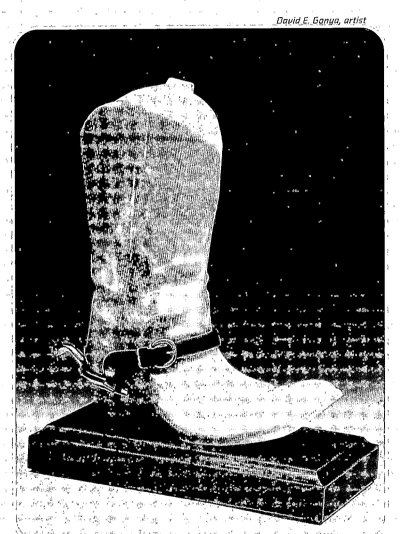

David E. Gonya, artist

Two floodlights bounced off of photo umbrellas were used to light this cowboy boot sculpted in stone. The right light was higher and closer to the work than the left one. The result is to illuminate a small portion of the boot's interior while focusing attention on the toe and body of the boot.

In this studio flashhead, the flash tube circles the lamp fixture. A simple tungsten bulb in the reflector acts as a modeling light, allowing the photographer to aim the flash and see how it will light the subject.

Electronic Flash

The development of the electronic flash marked a turning point in photography because it provided photographers with a reliable, repeatable, portable source of light. The first widely used electronic flash was Honeywell's "potato masher" style in the early 1960s. Today, flash units come in all shapes and sizes, right down to the dime-sized units built into compact cameras.

Flash units produce very short, powerful bursts of daylight-colored light (which makes it easy to use flash outdoors to supplement daylight). Unlike tungsten lights, electronic flash units (EFUs) use very little energy and run cold, not producing any heat until fired. A small amount of electricity—from either batteries or a wall outlet—charges the flash unit's capacitor, which releases its energy into the gas-filled flash tube, producing an intense burst of light.

Synchronization

The burst from an electronic flash is extremely brief (usually less than 1/2000 second). This causes a couple of issues unique with flash:

Most digital cameras come with a built-in flash. The pop-up style on this camera usually requires you to press a flash button to make the flash rise above the camera body. Be careful when using a built-in flash at close range because the lens will usually cast a shadow across the subject.

1. The first is synchronization. Cameras that have a focal-plane shutter (most digital cameras) must fire the flash when the shutter is open across the entire frame. The fastest shutter speed at which this occurs is called "the flash sync speed." When an exposure with flash is made at or below the flash sync speed, the whole frame will be exposed at one time. If a shutter speed that is faster than the flash sync speed is used (actually most recent cameras won't allow this to happen), the entire surface of the sensor will not be exposed.

2. The second is that flash is difficult to aim because photographers cannot see the results until after they've taken the picture. This was more of a problem in the old film days. With digital cameras, the exposure can be viewed immediately in the LCD monitor and corrections can be made. Studio flash units have a mounting for a tungsten or quartz lamp in the flash head itself. These "modeling" lights usually sit within the circular loop of the studio flash lamp so they show how the flash will illuminate the subject. For object photography, where the subject isn't moving or changing, digital cameras provide a quick view of the image and you can always readjust the lighting if things don't look right.

Camera Flash Systems

There is no end to the choices when buying an electronic flash unit for today's digital cameras. D-SLR cameras and some EVF cameras have a hot shoe, which will accept an accessory flash unit and channel communications between the camera and flash. Today's digital SLR cameras offer many flash options, from small built-in units to specialized close-up flash and everything in between. The D-SLR manufacturers have taken a systems approach, starting with basic units through advanced wireless multiple flash capability.

Digital SLR cameras use an interesting strategy to get the correct exposure with flash. It is called "Through-The-Lens" (TTL) metering. When the flash goes off, this system reads the light coming through the lens and turns off the flash output when it determines that the exposure is correct. TTL flash exposure is measured separately from ambient light, giving photographers the ability to separately control the flash and ambient light exposures.

Digital SLR Flash Systems: Manufacturers offer a range of choices in their digital flash line up. Because most are designed to work within a system, the units are designed to stand alone or work together.

• Built-in camera flashes. These small pop-up flashes are pretty weak, have a limited range of about 2 – 10 feet (.61 – 3.05 meters), and are sources of quite harsh direct light. Some cameras' built-in flash units will act as controllers in multiple flash setups.

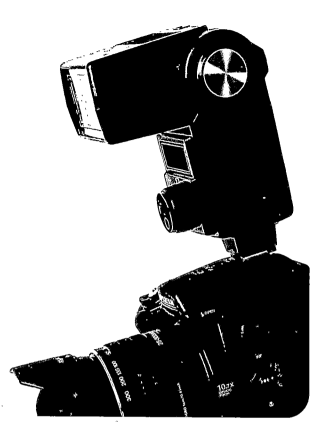

○ Small external electronic flash units. These accessory units offer more power than built-in EFUs. They can be mounted in the camera's hot shoe or taken off-camera with a dedicated cord. Useful for many photo requirements, small EFUs make excellent fill lights in multiple flash setups.

○ Top of the line accessory flash units. Most D-SLR systems offer a couple of choices of EFUs at the top of the range. These large, powerful units usually include features such as: multiple TTL modes, choice of flash sync options, power control, manual flash, swivel and tilt zoom heads (which match the coverage of the lens in use), built-in diffusers, multiple-flash control, etc.

○ Specialty flash units. Some camera manufacturers have added specialty EFUs to their digital SLR flash systems. These include flash units designed for close-up work, such as ring lights, and units that function only as powerful controllers in multiple flash setups. If you have specialty flash requirements and are about to move up to a digital SLR camera, make sure that the manufacturer's flash system fully meets your needs.

○ Multiple flash. Again, some camera manufacturers offer camera/flash systems that automatically control exposure in multiple flash setups. EFUs can be set up to act as master or remote units, and you can fully control lighting ratios so that one unit acts as the main flash while others produce fill. Some manufacturers even offer multiple flash systems that can be controlled wirelessly.

○ Accessories. There are many accessories available from camera manufacturers for their flash systems. These include dedicated connecting cords, multiple flash connecting cords, AC adapters, diffusers, etc.

In addition to some of the accessories listed above, aftermarket manufacturers also produce an interesting array of flash accessories (check with your dealer for compatibility). The most notable of these include:

○ Small light modifiers. These attach to accessory flash units and are generally used to diffuse the light or to bounce it and direct it toward the subject. Some also hold filters or other types of diffusion material.

○ Large light modifiers. These include umbrellas, softboxes, and other types of portable reflectors in many sizes, colors, and shapes.

Brackets: There is a flash bracket for every photographic need. These allow you to take a flash off-camera (using a dedicated connecting cord to maintain TTL automation) to achieve more natural lighting. Some close-up brackets will even hold more than one unit so that you can have a "mini lighting studio" attached to your camera.

Studio Lighting

These lights are generally less portable and more expensive, but if you want a studio setup, you may want to consider them.

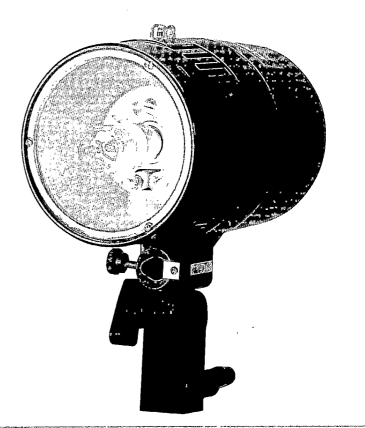

Courtesy Opus Pro Photo Lighting Equipment

Monolights: These are self-contained flash units about the size of a quart container of ice cream (or larger). Mounted on a stand, a monolight contains the flashtube, a modeling light, large storage capacitor, and electronics for adjusting the flash. They usually run on household AC but draw less current than hot lights. Comparatively inexpensive, they are useful for all sorts of object photography.

Flashheads and Power Packs: Instead of an all-in-one unit, the flashtubes and modeling lights are housed in a fixture that attaches with a heavy cable to a large power pack. These systems are usually much more expensive than monolights and draw more current. However, they offer more output and the ability to control several lights from one place.

Studio Lighting Accessories: There is a broad range of supports, diffusers, and reflectors for studio lighting setups. Other modifiers–to numerous to mention here–include barn doors, scrims, and snoots.

This Lowel EGO fluorescent is good for tabletop photography. It produces smooth, diffused light that works well with many types of art. Note the white reflector opposite the light that comes with the EGO. It bounces light into the unlit side of the object to soften the shadows.

Fluorescents

A number of fluorescent lighting systems have been developed in the past few years for digital photography. These lights are based on new daylight-balanced, flicker free, fluorescent lamps that have the advantages of being inexpensive, easy-to-use, and cool.

One of the most interesting of these new fluorescent light designs is the Lowel EGO light. This system has a color temperature of 5500K (daylight) and a life of 10,000 hours. It consumes only 54 watts of power, but puts out the equivalent light of a 200-watt tungsten lamp. In use with a camera set to ISO 100, the EGO produces an exposure of about f/11 at 1/15 second. Because it is only 16" tall, the EGO is very useful when shooting subjects that are less than a foot tall: small ceramics, some glass pieces, and a lot of jewelry.

A point-source of light creates harsh contrast with deep shadows (left). Diffusing the light, for example by bouncing it off a white poster board, produces less dense shadows and more pleasing overall lighting (below).

Light Modifiers

Controlling the quality of light is critical to making good photographs. To manage and modify light, many different types of devices and techniques exist. Some of these alter the quality of the light by softening it, while others change both the quality and color of the light by bouncing it off different colored or textured surfaces.

All of the types of artificial light described so far are considered hard light sources. They emit harsh light and create deep shadows and plenty of glare, which are problems for use in object photography.

So how can this light be softened? One way is to place something between the light and the subject to change the quality of the light. Over the years photographers developed many tools to accomplish this in the studio. Happily, in recent times, more and more clever light modifiers have become available for photographic use. Let's take a look at some of them.

The white reflector is only inches from the doll's face. With small objects, you can keep lights and modifiers near the work but just out of the image frame.

Reflectors

The simplest way to soften or diffuse a light source–or reduce its contrast–is to bounce the light off of a white wall. This is easy to do in a small, white-walled studio. Simply point the lamps toward a wall and bounce the light onto the subject.

A much better reflector is also one of the simplest: a piece of white foam board or poster board. These large white cards are handy to have around the studio. They are the big brothers of those little white cardboard or plastic bounce cards used by press photographers and paparazzi on their camera flashes.

Instead of walls and white poster board, you can get all sorts of ready made flat reflectors. These fabric reflectors come in gold, silver, soft white, and other surfaces that not only soften light (soft white surface), but can warm it up (gold surface) or add some sparkle (silver). There are square reflectors and circular reflectors. They work equally well and come in sizes from 6 inches (15.2 cm) to 8 feet (2.44 meters) in diameter. The reflector material is held in place on a flexible metal frame. With a twist of their frames, these reflectors collapse and fold for easy storage.

It may look like protection from rain, but the real purpose of a photo umbrella is to bounce and soften the light. It attaches to your light source with the inside facing the object.

Umbrellas

Another type of light reflector is the photo umbrella which looks like an ordinary rain umbrella. The big difference between the two is that the photo umbrella is made out of the same material as reflector disks. Again, there are color choices of white, silver, gold, and more.

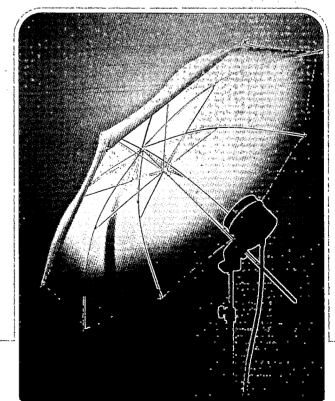

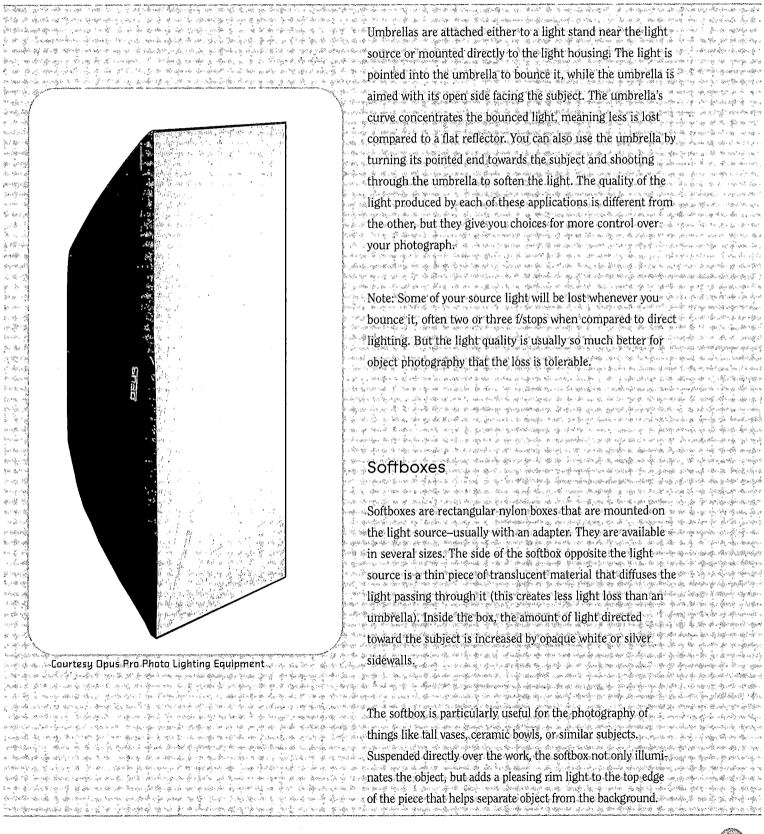

Courtesy Opus Pro Photo Lighting Equipment

Umbrellas are attached either to a light stand near the light source or mounted directly to the light housing. The light is pointed into the umbrella to bounce it, while the umbrella is aimed with its open side facing the subject. The umbrella's curve concentrates the bounced light, meaning less is lost compared to a flat reflector. You can also use the umbrella by turning its pointed end towards the subject and shooting through the umbrella to soften the light. The quality of the light produced by each of these applications is different from the other, but they give you choices for more control over your photograph.

Note: Some of your source light will be lost whenever you bounce it, often two or three f/stops when compared to direct lighting. But the light quality is usually so much better for object photography that the loss is tolerable.

Softboxes

Softboxes are rectangular nylon boxes that are mounted on the light source—usually with an adapter. They are available in several sizes. The side of the softbox opposite the light source is a thin piece of translucent material that diffuses the light passing through it (this creates less light loss than an umbrella). Inside the box, the amount of light directed toward the subject is increased by opaque white or silver sidewalls.

The softbox is particularly useful for the photography of things like tall vases, ceramic bowls, or similar subjects. Suspended directly over the work, the softbox not only illuminates the object, but adds a pleasing rim light to the top edge of the piece that helps separate object from the background.

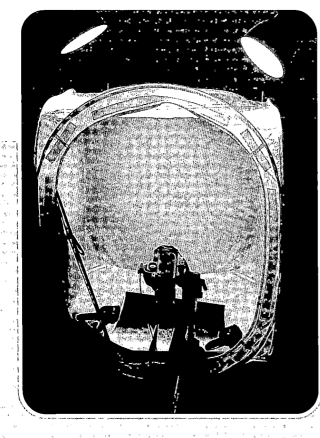

A light tent creates an environment that is like an overcast day. This one is a 24 inch cube (61 cm), which is large enough to use with objects that are 12 inches in height (30.5 cm) or shorter.

Light Tents

Light tents take the logic of the softbox one step further. Instead of surrounding the light source with fabric to soften it, the light tent wraps its fabric around the subject. While the softbox softens a single light source, the light tent softens all the light falling on the subject. This advantage allows you to use several light sources simultaneously, placing them in different positions around the tent. It is as though an overcast day has been created inside the light tent, making it particularly useful for shooting shiny objects.

Light tents are made of white translucent materials mounted on flexible metal hoops. Like photo reflectors, light tents come in a variety of sizes but can collapse and fold for smaller storage. As a rule of thumb, the tent should be larger than the object being photographed. For example if you shoot jewelry, an 18 inch square (45.7 cm) tent should be your minimum size, but a 24 inch square tent (61 cm) will give you much more working room. For bigger subjects, objects that are perhaps 15 – 24 inches (38 – 61 cm) tall or wide, for

example, I use a 48 inch (121.9 cm) tent. Not too long ago there were only a couple of expensive light tents on the market. Now there are dozens of inexpensive models available.

There are also small plastic domes available that are placed over your piece to diffuse light. They work well with some objects, however their use is limited because they only offer one shooting distance and one angle of view (straight down) of the subject.

In addition, a number of companies offer complete tabletop studio kits at reasonable prices. These kits typically include a small light tent, a backdrop, and two small lights on short tabletop light stands. I have used several of these, and my biggest concern is that the lights are often too weak for the results I'm after. That said, I do think these kits are well worth their rather modest costs.

Measuring Light

There are numerous combinations of shutter speeds and aperture settings that will allow the right amount of light to reach the sensor, producing correct exposure. With all these lighting and accessory choices, how do you know what camera settings to use? You can measure the light in a scene with either the camera's built-in meter or an accessory hand held meter that helps you determine effective exposure settings.

In-Camera Metering Systems

Built-in exposure metering systems in digital cameras read the light reflected off a subject and are designed to find the proper exposure in a wide variety of situations. Your particular camera may or may not offer all metering selections described in the exposure section (see page 29-33). Learn how to work with the options available on your camera whether they are evaluative, center-weighted, or spot. Of these, spot metering can be especially useful in the studio for shooting objects.

The ability of a spot metering system to measure the exposure of a specific area of a subject can be critical. When photographing objects on sizeable expanses of white or black background, metering systems that read these large areas of the background can misinterpret correct exposure for the subject. In addition, translucent subjects create challenging exposure situations, as bright areas of glass, for example, can cause incorrect exposure readings.

With the built-in exposure metering set for spot metering, correct exposure in such situations is easier to determine. Find an area of the subject that is close to middle gray in tone (not color). This is a darkish tone something like that of new denim jeans. Using either the viewfinder or the LCD monitor, move the target for the spot meter over the area you want to read. On many cameras you can set this exposure by pressing and holding the shutter release halfway. Keeping pressure on the shutter release, recompose and finish pressing the shutter release down to take the picture. Many advanced digital cameras have an Auto Exposure Lock (AEL) button that makes reframing easier by maintaining the exposure readings you've made.

Accessory Exposure Meters

Sometimes even sophisticated in-camera metering systems can make exposure mistakes. They can have trouble reading the right exposure in complex lighting situations where multiple light sources may be used, with back lighting, or when shooting with studio flashes.

For either continuous light or a flash reading, hold an incident light meter in front of the subject with its dome pointed at the camera.

When working with external electronic flashes, a hand-held exposure meter with flash reading capability is essential. Unlike in-camera meters, most hand-held meters are incident reading. They measure the light falling on (incident to) the subject rather than the light reflected off it. Incident light meters are easily recognized by their prominent white plastic measuring domes. These domes act as diffusers that average the light falling on the meter. The ability to read incident light is useful with highly polished objects and complex lighting.

Camera TTL systems are designed to work with built-in flashes or dedicated external flashes, but they do not work with separate studio strobes. So a hand-held flash meter is an absolute necessity if you use studio flash. To operate a flash meter, plug the sync cord that usually goes to the camera from the strobe into the incident meter from the strobe and fire the flash with a button on the meter. The intensity of the flash is measured and an aperture reading displays on the meter. Once this exposure is found, set the f/stop and reattach the sync cord to the camera for picture taking. In flash mode, the camera's shutter speed is always set at the camera's sync speed or slightly slower.

One of the great advantages of digital photography is the ability to take a photo and see the results immediately on the camera's LCD monitor. Examine the image to see if you have exposed it properly. If it looks overexposed or underexposed, you can fine-tune the lighting and re-shoot as necessary. Don't forget to take advantage of the histogram.

METERS SEE IN GRAY

When light meters read a scene, they mix all the light intensities into one and tell you how to set the camera based on that average tone. Their single-minded goal is to render the whole world as a solitary tone of neutral gray.

A simple way to see and understand this process of average gray is to point your camera at a white wall and take a photo. Then point the camera at a black wall and take a photo. View these images and you'll see two nearly identical gray frames.

This tendency toward gray is a problem that photographers often encounter. Shoot an object on a white background and the photo you get could end up as a black object on a gray background. Shoot on a black background and you might get a washed out subject on a gray background. We will soon learn how to properly expose for important areas while compensating for a metering system that becomes overwhelmed by large regions of light or dark background in the scene we are shooting.

Backgrounds

Central to object photography is the idea that you don't want to see anything but the subject in the photo. It is best to keep images as simple as possible. Please: No children, boyfriends, girlfriends, dogs, cats, garage doors, rumpled linen, patio decks, or flowers in the picture. Including extraneous things in your object images is like screaming, "I am not serious!" It sounds like a no-brainer, but many people submit images to juried competitions or post images on Internet auction sites with distracting additions included in their photos. So, the purpose of the background is to eliminate everything irrelevant from the frame so the viewer can focus attention on the subject.

Solid Colors

The simplest backgrounds are simply large pieces of white or colored paper, poster board, or commercially produced seamless paper. The term seamless refers to using a background to eliminate a horizon edge, break, or line at the place where the wall meets the floor or table. To achieve this effect, the background material is hung with a gentle curve—not a fold or crease—in the paper where the wall and floor surfaces would meet. Commercial seamless background paper comes in various widths, lengths and colors.

The size of your background depends on the size of your objects. A background should be about twice as long as the largest dimension of the object. A silver pendant that's 2 x 3 inches (5.1 x 7.6 cm), for instance, needs at least a 5 x 7 inch background (12.7 x 17.8 cm). A ceramic vase that's 20 inches (50.8 cm) tall and a few inches wide requires at least a 40 inch (101.6 cm) tall background.

TABLETOP BACKGROUNDS

As an accessory to the EGO fluorescent lighting system, Lowel also sells a product called the EGO-Sweep. This is a white plastic background stand that is supported from behind. It is compact and versatile. Place any of the 10 large colored background papers that comes with the Sweep and it instantly becomes a seamless background.

The Sweep above is placed on a table top with yellow seamless conveniently attached. It is quick to set up and compact to fold down and store.

This close-up of my collectible Jim Beam "Schnapps-O-Flex" bottle shows how well the EGO works with shiny areas.

Choosing the correct background for a particular piece is important. When selecting a background, keep in mind the concerns for color contrast (see page 47-48). It is helpful to know how certain backgrounds work with different subjects.

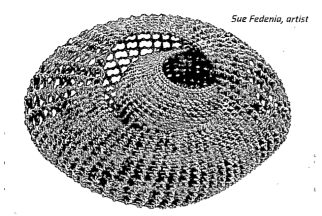

Sue Fedenia, artist

A white background works with some objects better than others. This basket-in-a-basket required a white background to illustrate the piece's open structure and to let you see into it.

White Backgrounds

White is the simplest background. From a sheet of letter-sized white paper to a large roll of seamless, white has many uses because it makes your object appear to float in space.

I like white backgrounds for certain website purposes. Look at some well-known Internet sites (Google and eBay come to mind) and you will find the background color of the screen is white. If you plan to use your images on a web page, shooting them on a white background will have a pleasing visual effect.

For other uses, white doesn't work as well. Dark objects can appear to recede from the viewer, which is not very useful in photos of objects for jury submission or ads.

Black Backgrounds

Black is also commonly used for the photography of objects. Bright or richly colored objects look very dramatic and intense when photographed on black. But black doesn't always work either. Reflective surfaces, and particularly the reflective edges of shiny objects, will reflect the black background causing their edges to merge with the background. This results in the work losing its shape. Neutral or earth toned subjects don't work on black backgrounds either. The black takes the muted tones and mutes them even more.

A black background can create a really dramatic presentation. In this case, black is a good choice because the surface of these matte earrings doesn't reflect the dark background.

Ala Jaron, artist

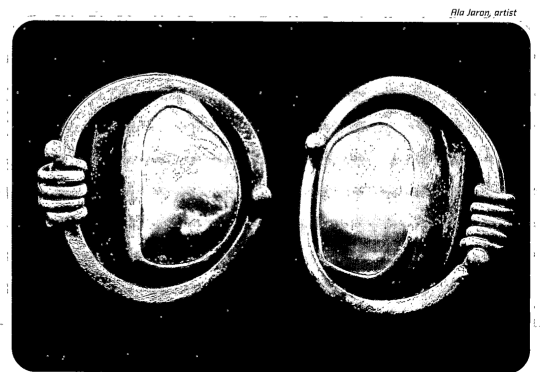

A santon is a traditional doll that represents the residents and trades people of Provençe. This French lavender gatherer does not stand out well when photographed on a green background (right). However, notice how the santon pops from the photo (below) when she is photographed in the same light with a graduated backdrop.

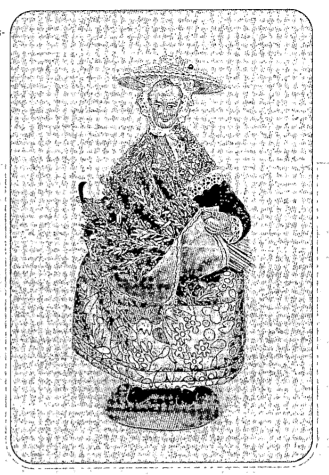

Vividly Colored Backgrounds

Bright hues such as yellow, blue, and saturated red add visual pop and sizzle to a picture, but it is wise to use them judiciously. Intense colors can easily overwhelm a subject and blind the viewer.

Beside paper, other materials can work as backgrounds. Glass, Plexiglas, linoleum, ceramic tiles, and shiny fabrics all have their places.

Graduated Backgrounds

Over the years, the use of graduated backgrounds has become an increasingly popular way to photograph art, craftwork, and objects to display on the Internet. Typically these backgrounds are black at the top and gradually become lighter (nearly white) at the bottom. This gradual transition of tone creates a spotlight effect. The subject sits in an area of lightness in front of a large mass of darkness, focusing our attention on the piece.

The transition of tones has a psychological effect upon the viewer that short-circuits some of the simultaneous contrast problems (see page 47) you normally run into with solid colors. For instance, jewelry in colors like silver and gold don't work well with solid backgrounds. Because of simultaneous contrast, these materials are easily contaminated by the colors around them. But put silver or gold on a graduated background and they look right.

There are several ways to create a graduated background effect. One is to use a small spotlight and a paper background. Hang the background so that the paper extends a good distance from the wall. Then place the work on the paper as far towards the front as you can. Suspend a light source above and slightly behind the work, pointed down at the flat part of the background so that little or no light reaches the vertical part of the background.

Another method is to use a sheet of translucent white acrylic supported approximately 12 – 24 inches (30.5 – 61 cm) above a table surface, perhaps on two stacks of books. Place a spotlight below the work pointed up at the acrylic. Adjust this light and its reflector to create a circle of light in the center of the translucent acrylic. Place your subject in this circle of light for the photograph.

The simplest and most effective way to get a graduated background is to buy one. Rolls of vinyl-coated paper are sold under a variety of brand names and graduated colors. Hang this background, dark side up with a smooth curve at the wall, and you are ready to set up lights for a wide variety of subjects.

I use these backgrounds a lot and they are generally very good. But there are a couple of downsides. They cost a lot more than plain seamless paper and are available in only a few sizes, none of which are small enough for things like earrings or coins. In addition, they are vulnerable to scratching and can be ruined after just a few uses. However, I recommend them for a number of uses (see the Resource section beginning on page 152).

Lori M. Sandstedt, artist

BEHIND THE SCENE TIP

Graduated backgrounds come in many colors and styles, but the most useful type is the black to white. I like it because it provides me with a wide range of tonal changes. By placing my subject on different parts of the background, I can get different effects.

Setting a work on the white portion and laying out the background so the darkest part is visible behind the piece makes a dramatic image. For a softer look, I suspend the background more vertically and place the object in a gray area with a more gray behind it. Or I can lower the top of the background and place the object on a darker gray area with black behind it for a dark (but not black) look.

You can't do that with solid colors.

Tripods and Remote Releases

Finally, tripods are an invaluable accessory in your studio for shooting craft and collectible objects. So if you don't have one, invest in a good tripod. There are at least four reasons why a tripod is required:

1. They eliminate blur due to camera shake. Especially when shooting close-ups, camera movement is magnified and even the slightest motion of your hands when holding the camera is enough to blur the picture.

2. They eliminate blur due to long exposure times. Stopping down a lens to get the maximum depth of field means that you have to use longer exposure times, i.e. slower shutter speeds, to get the correct exposure. It's hard to get sharp pictures holding a camera at shutter speeds slower than a 1/30 of a second.

3. They help maintain framing during close-ups. The slightest movement, like pressing the shutter release, can throw off the framing of a close-up photo. What you thought was a well-framed subject can easily end up in one corner of the frame because of this.

4. They make repeatability possible. You can take multiple identical images when using a tripod. If the first photo doesn't look the way you want, you can simply make corrections and shoot another while maintaining the original framing.

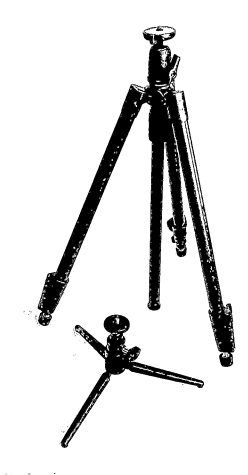

Tripods are essential for shooting sharp images. Despite its tiny size, the little tripod is handy when shooting small art pieces and jewelry using a tabletop studio setup.

Tripods are available in many sizes and materials. In trying to select the right tripod, think in terms of two factors: stability and comfort.

Stability means that the tripod can support the weight of the camera and lenses you put on it. Most point-and-shoot cameras weigh about half a pound. EVF cameras weigh a pound or less, while a D-SLR with a big lens can weigh several pounds. Get a tripod that is designed to support the camera you plan to use, and add a few pounds as a safety margin. Don't try to save money by buying a tripod that can't support the weight of your camera, lens, and flash unit.

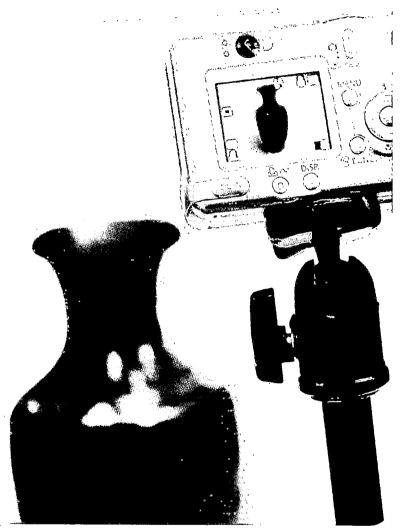

Ballheads are infinitely positionable with the simple release of one screw or lever. I prefer them because of their "one stop" ease of use.

Always handle a tripod before buying. If it feels cheaply made, it is a disaster waiting to happen. The maximum extended height of the tripod is very important too. You want the tripod with mounted camera to come comfortably to your eye level, so you can stand behind it during a photo session without stooping all day. Also consider a tripod that doesn't have to be fully extended to reach eye level, because tripods will not be as rigid when the column is all the way up.

Tripods have two parts: the base or legs portion and a head. These can be bought together or separately. I prefer legs with snap locks that flip open to extend the leg. The head allows you to control the position of the camera. There are several

types of tripod heads. One type is the pan/tilt head, which has controls (often extended arms) to set the horizontal and vertical position of the camera. A third control knob allows the camera to be rotated, or "panned," in a circle.

Another popular type of head is a ballhead, or ball-and-socket head. The camera is screwed into a metal ball that sits in a circular socket, and a single lever locks and unlocks the ball to position the camera. I prefer this type of head because its nearly infinite number of positions allows more subtle control of the camera.

Remote Releases

A remote release allows you to trip the shutter without actually touching the camera. It complements the tripod, reducing even further the chance of blur resulting from tripping the shutter.

Another way to remotely release the shutter without causing vibrations is to use the self-timer control built into most cameras. The original purpose of the self-timer was to allow the photographer to get into the picture, but in inanimate object photography, it can be used to reduce camera shake. I use the camera's self-timer control in the studio to eliminate camera shake during long exposures.

To use the self-timer on most cameras, go into the camera's menu and look for the self-timer setting, often a clock icon with a number (representing the delay time) found in the Drive mode. Once set, when the shutter release is pressed, there will be a few seconds delay before the exposure is made.

Many digital cameras accept a small wireless remote that works like a TV remote control to trip the shutter with an infrared beam. To use this type of remote, look for the appropriate icon or setting in your camera's menu system. You can set the camera's exposure controls, step away, and fire the shutter from a short distance.

Instead of using infrared, you can also get accessory remote releases that are dedicated for your D-SLR. These are a foot or two long and fire the shutter at the touch of a button.

Details should be sharp. Using a remote release while your camera is securely set on a tripod is the surest way to get the sharpest pictures possible.

photographing two-dimensional objects

Whether large or small, two-dimensional objects are best photograhed using a seamless background. For large pieces, I hang the work in front of background paper or other material mounted on a wall. With smaller artwork, I'll drape the seamless on a table top so no horizon line appears. Either way, the idea is to make the work appear as if it is floating in space. Remember to use a background that is at least twice the longest dimension of the object so that nothing except your object and background appears in the frame.

Once the backdrop is up, hang the artwork as flat as possible. To make this easier, I've cut a small hole in one of my backdrops to go around the frame hooks on my studio wall. Since a painting on a hook or on a wire tends to angle forward a bit, I sometimes use museum putty to help keep it straight.

Whenever I'm shooting arts, crafts, or collectibles, my physical comfort is a primary concern. I don't want to stoop and bend over a short tripod for hours when taking pictures. Set your tripod and hang backgrounds within a comfort zone based on your height and eye level. A little bending is okay; stooped over like the Hunchback of Notre Dame is not.

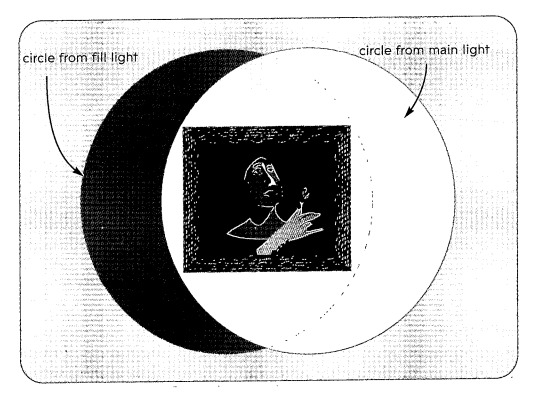

circle from fill light

circle from main light

Photographing two-dimensional art requires uniform lighting across the entire work. The circle of light from both sources should cover the work with over lapping light, as illustrated.

Lighting Paintings and Other Flat Subjects

Two-dimensional art, with a few exceptions, needs to be lit uniformly. Lighting artwork well is important because poor lighting will produce a poor photo.

Place lights with reflector housings on either side of the work, about half way between the art and the camera (see basic studio illustration on page 50.) The lights should be at the same height as the center of the artwork and angled so the circles of light overlap as shown in the illustration above.

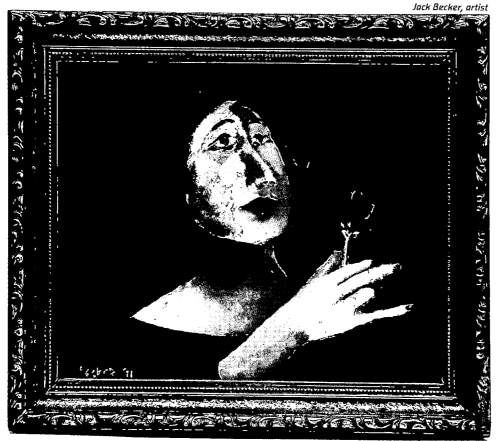

This painting is uniformly illuminated by matched 250-watt tungsten lights, providing even lighting but still showing some shape and texture in the frame.

The pencil test, or in this case the ballpoint test, shows that the illumination from the two lights are matched. Two shadows cast by the pen are of equal intensity and are cast at matching angles.

Begin by darkening the room. Point the lights at the work and turn them on one at a time, adjusting each to illuminate the entire subject. The lighting should look smooth across the whole work. Take a pencil or ballpoint pen and hold it on the center of the work perpendicular to the surface. The shadows cast by the two lights should be equally dark. If the shadows are not the same, move the light producing the darker shadow father away, or the one producing the lighter shadow closer. The angle of the shadows should also correspond. If they don't, adjust the position and height of the lights until the shadows match.

To further insure that the work is uniformly lit, take exposure readings from the center and each corner of the work. Setting your camera to spot metering, zoom to your longest telephoto setting. Then place the metering area (as marked in the viewfinder display) at the center and at each corner of the work, pressing the shutter release halfway to take meter readings. The correct exposure is displayed in the viewfinder.

The exposure reading at the center should be the same or very similar to those at each of these corners. If not, readjust the lights so that the readings match as closely as possible. Then I take a test shot and check the camera's monitor to see if the illumination is right.

Since the distance from the camera to the corners of the work is greater than the distance to its center, set the lens aperture to at least f/8. A small aperture is needed to provide sufficient depth of field to make the corners as sharp as the center.

Determining exposure can sometimes be tricky with flat artwork. A pen-and-ink sketch with a lot of white space, or a painting full of dark colors, can fool the camera's exposure meter. I shoot art using Manual (M) exposure mode. If a test photo looks too dark or too light on the camera's LCD monitor, I can reset the aperture, opening it a half to a full stop if the image is too dark, or closing down by that much if the image is too light. Checking the histogram if your camera has one can also help determine satisfactory exposure.

If you are shooting in the AUTO or Program modes and your images are too light or dark, you can use your camera's exposure compensation control to add or subtract exposure. If white or light subjects are too dark, try setting exposure compensation to + 1/3 or +2/3. Similarly if the image of a dark subject is too light, set this control to -1/3 or -2/3.

Another way to get correct exposure with a difficult subject is to take an exposure reading from a neutral gray card, manufactured specifically for this purpose.

Squaring Up

Unless you intentionally make oddly shaped frames, you should make sure the vertical and horizontal sides of the work are parallel to all edges of the viewfinder frame (squaring up the art in the frame). A piece of art that is just slightly askew will look like it is falling. Distorted, or keystoned, artwork looks bad and turns off jurors and buyers alike.

The first step is to frame the work in the viewfinder. Check to see that the camera back is parallel to the subject. If not, adjust the camera and reframe the image so that the edges of the work are parallel to the sides of the viewfinder frame. This gets you very close to the proper square, but there's an even better way with many digital cameras.

Camera menus often offer the choice of several different screen displays. On many cameras, one of these is a grid display consisting of vertical and horizontal lines that appear in the viewfinder and on the LCD monitor. A grid serves as an aid to squaring-up an artwork, letting you align the grid lines with the object you are shooting. (If you shop for a new camera, consider this feature because it can save you hours of frustration minutely adjusting camera and art.)

Even with a grid display, it is sometimes difficult to tell from a small LCD monitor whether your image is correctly squared up. You can check this in the computer when you open your file in an image-processing program. Many of these programs have tools that adjust the image to look more square (see page 135).

Texture in this piece of art is highlighted by a combination of glare and shadows. The lights were bounced off poster board rather than diffused by a lightbox or similar modifier.

Dealing with Glare

There are three primary sources of glare that can affect your photographs of flat art:

1) Glare off the surface of the art work (for example, an oil painting).

2) Glare from the frame glass.

3) Glare off the frame.

To reduce glare, begin by moving each light back on its respective side of the object. If this fails to cut glare, try softening the light by using light modifiers, like a photo umbrella or placing a translucent panel in front of the lights. Glare is the reflection of the light source, and the more it can be diffused (the larger the illuminated surface of the source), the less glare.

Note: Glare needn't be totally eliminated. Small hot spots or bits of shine can help the viewer get a feeling for the textural quality of the art. Without a little sparkle, the surface can look too flat and dull.

Color Accuracy

Moving and diffusing lights will generally reduce glare, but art under glass may require additional steps because glass is so reflective. I advise removing the glass whenever possible since it adds nothing to the artwork. Besides being a glare nuisance, glass or translucent acrylic can lower the saturation of colors.

A traditional remedy to reduce this type of glare is to use polarizing filters. Set in rotating mounts, these filters fit over the camera lens. Looking through the viewfinder, you rotate the filter until the glass reflection is diminished. However, a polarizing filter may not eliminate all of the glare, and it blocks about half the available light from getting to the lens.

Some photographers also place big polarizing filters over the lights, though this is not ideal. Besides the light loss (which can be huge with filters on both camera lens and lights), polarized light may shift contrast and color saturation. Why spend lots of time trying to get around the glass problems? Unless the glass is absolutely necessary to keep the artwork flat, the best strategy is to un-frame the work and, if the frame itself is important, reframe without the glass.

Every step in the process of making an image has an effect on color: light source, kind of background, type of camera, printer, inks, paper, and PC monitor. Getting the colors right in images is very important, yet with so many factors involved, it can also be very difficult.

It is important to set the camera's white balance control to match the lighting (see page 35), otherwise it is likely you will get a color cast. In addition, many digital cameras have an option for selecting color space. Color space is usually found in a camera's menu system and is used to set the way in which a camera records color for reproduction on a computer monitor (sRGB) or a printer (Adobe RGB). Often there are other color settings, like Vivid or Hot or Saturated, in which the camera processes and saves the colors in more intense, saturated levels. Since you can always saturate colors in an image-processing program, it is better not to record the image in a saturated setting.

If available in your camera, RAW or TIFF files, which are uncompressed by the camera's image processor, can sometimes produce cleaner colors. Try a few experimental shots in different formats (RAW, TIFF, JPEG) and compare to see if you notice differences in color rendition.

Different objects sometimes create difficulty in getting accurate color, particularly if you are making images of paints or fabrics. Fluorescing agents added to many paints and fabric dyes can distort colors and reflectivity by absorbing UV (ultraviolet radiation) from light. Under certain conditions, this can cause white areas of the image to wash out or turn

blue. To see if the artwork you are shooting has this problem, get a black-light UV lamp. View your objects with this light to see if any areas glow bright blue.

Sunlight, electronic flash units, fluorescent lights, and even tungsten studio floodlights all produce UV radiation. If the object fluoresces under the black light, it will fluoresce with these other lighting sources. What can you do?

Well, there is a surprisingly simple solution to this problem. Shoot the artwork or fabrics with inexpensive household lamps. Normal soft white household lights produce yellow-red light and very little UV. Without a UV light source, the added agents and dyes won't light up. You might need to use several 100 or 150-watt bulbs to replace a single floodlight or flash to get the overall lighting level high enough, but these will reduce or eliminate most fluorescing problems.

Metamerism

Another problem that occurs largely with fabrics is called metamerism. This is when two colors appear to be the same, but look different when viewed under some types of light. Because fabric dyes (and paint for that matter) are chemical formulations, the colors they produce depend upon the molecules in the chemicals and the color of the light source. There are thousands of formulations, and different companies often use different dyes to produce the same color. But these dyes can react differently with some types of light, so two pieces of fabric seemingly the same color may not look that way under another type of light. A real world example

occurs when you buy a matching shirt and pants that looked great in the store but don't appear to match when you see them outside in sunlight. There isn't much you can do about this except to find a light source under which the colors look similar.

The difference is subtle, but under tungsten light (top), the colors of the two sweatshirts are indistinguishable.

Under daylight, the two gray fabrics look slightly different, with the top shirt showing a red cast.

Fabrics

The first step in photographing two-dimensional fabric work is to iron these pieces whenever possible so they are flat. It becomes distracting if ripples and folds are apparent in these pieces. When shooting fabrics, think about what is most important to show in a photograph. There are three elements to keep in mind:

1. The material's texture and color.

2. Form and design of the work.

3. Style and function.

Each element calls for a different photographic approach, so deciding which factor you want to concentrate on will make your photography work a lot easier.

For example, if photographing a hand-painted silk tie, shape is subordinate since almost all ties are long and skinny. The element that sets such a tie apart from others is the texture and color of the material, especially the hand-painted design. Consequently, the camera should be close enough to the tie for the painted portion to dominate the image while the lights are set to emphasize the lightness of the material.

On the other hand, if the subject is a runner for a small table, cut and embroidered from commercial material by an artist, the form and style of the material are the primary factors. Your task is to recognize which aspect of the fabric object is most important and to shoot accordingly.

Lighting Fabric

Some fabric work is three dimensional. But a great deal is two dimensional, even if it includes small elements of mixed media that may be three-dimensional. So let's take a look at lighting for two-dimensional pieces. (Lighting for three-dimensional fabric work will be described later.)

The position of light in the horizontal plane controls texture. When a light is directly in front of a subject, texture is minimized because there are no shadows. As a light is moved around the work, to positions of 30 – 90° to one side of the subject, its textural quality increases as the shadows deepen and lengthen. Shadows are caused by unequal lighting, and controlling the depth of the shadows is the key to shooting textured fabrics.

When your two lights are of equal intensity and equally distant from the subject, the lighting ratio between them is said to be 1:1. The shadows created are very slight because the light coming from each side of the subject is equivalent. However, I can make either of these two lights be the main or the fill light by changing their intensity or distance. The main light illuminates the subject and provides the highlights, while the fill is weaker, putting a measure of light into the shadows. When I make the fill light dimmer, or move it away, the textural shadows darken. For most fabrics, the difference between the main light and the fill or second light should be about a stop.

photographing two-dimensional objects

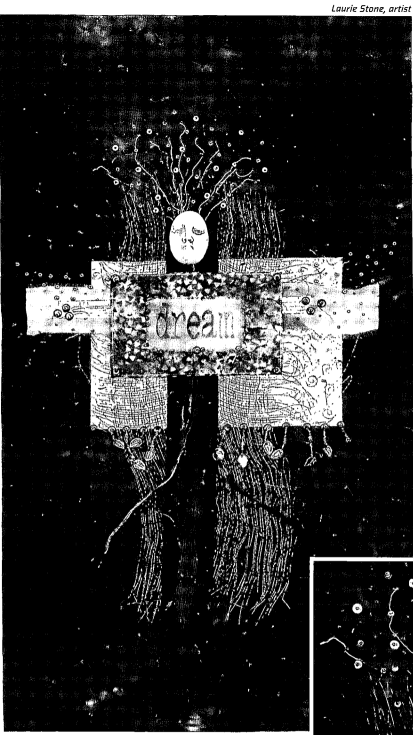

This close-up clearly demonstrates that moving the fill light away from the work just a little creates a slight shadowing that gives texture to the work.

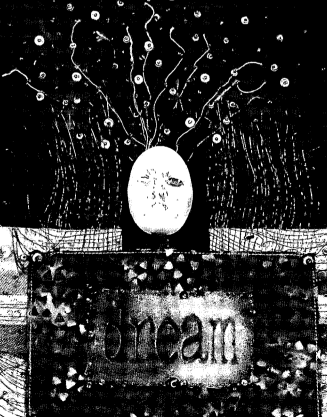

Shadows reveal texture, so I lit this mixed media quilt to show very slight shadows, therefore illustrating the elements of this work that are three dimensional. There's no fixed rule to placing the lights, but I tried the second (fill) light in several positions until I had the look I wanted: light shadows that are barely visible.

Hang fairly large pieces of fabric at a comfortable height, as though you were photographing a painting. Place the main light to the left of the piece, at a distance of about six feet (1.83 meters), but unlike shooting a painting, place it higher so it points down at the work. Next place the secondary light opposite the main light and at the same height and angle.

Turn the main light on first and move it around horizontally until you get the textural look you like. Then turn on the second light and move it until the shadows are visible but now a bit lighter. Shadows record darker in photography then our eyes and mind perceive them, so don't simply rely on your eyes. After setting the lights, make a photo and review it in the LCD monitor to see if the texture–and the shadows–look right.

This works with any fabric, but the exact position of the lights depends on the material and its colors. Textures jump out of lighter colored material, yet need more creative lighting to be seen in darker colored fabric. You will need to experiment, moving your lights to find the best position for attractively presenting the texture of a particular piece.

This woven multimedia artwork hangs from a fabric cord. Photographing the whole work with its cord would have made the artwork smaller in the photographic frame, causing it to lose impact and clarity. The shadows on the right sides of the work are a clue that the fill light on the right was farther away from the work than the main light on the left.

Batiks, Macramé, and Quilts

I usually attach these kinds of pieces to a pole or heavy wire and hang them in front of the backdrop. The pole or wire can be supported by light stands, a couple of ladders, or even by two friends if they are handy. Fasten with as many clear plastic clips as needed across the top of the fabric to reduce any tendency to sag. Suspending work this way is especially useful with lighter fabrics like silk kimonos and sweaters.

Set up the lights as you would for shooting other fabric work. Place the lights to emphasize texture, as described earlier. Carefully look at the artwork: The shadows should be visible but not overly dark. Take a test shot and check the image. Depending upon how dark you want the shadows to be, move the fill light to lighten or darken them.

Large subjects such as bed-sized quilts or area rugs present additional problems. Because these pieces are big, it may be difficult to place your camera far enough back to get the whole piece in the frame. A wide-angle focal length is helpful. You will have to find a focal length that can be used with your camera that will allow you to frame large pieces within your studio space.

Of course a large shooting space is necessary if you want to photograph large pieces. For example, an 8 x 10 foot (2.44 x 3.05 meters) quilt needs a wall space of at least 12 x 14 feet (3.66 x 4.27 meters). That's a pretty high room! In addition, the room must be deep enough for the lights to be at least 15 feet (4.56 meters) from the work, and wide enough for the lights to be about 20 feet (6.1 meters) apart.

Rugs or quilts are often too heavy to hang safely on pole or wire. An alternative is to lay them on the floor (or on a backdrop on the floor) and place light stands on either side. Then climb a ladder and point your camera from 8 – 12 feet (2.44 – 3.66 meters) above the work, setting your lens to a focal length wide-enough to frame the piece. A grid screen comes in handy in these situations, and be careful to keep the ladder and light stands from appearing in the frame.

Even with a grid screen, it's hard to square up the work when shooting from a ladder, especially if you are handholding your camera or have it braced against a ladder step. If the images end up being a little distorted, you may be able to fix them using image-processing software (see page 135).

Sometimes you lose interesting details when photographing large pieces. Your image may well show the overall design and pattern of the work, but the texture, stitching, or weaving are difficult to record because of the subject's distance from the camera. If the fine detail is important, take a few close-up shots of representative areas of the work. Later in the computer you can insert these details into the photos of the whole work, or present them separately.

Scarves, Ties, and Table Runners

Long, thin pieces like scarves, ties, and table runners have no visual impact when presented as a straight line. For these objects, texture and color usually trump style and function or form and design unless there is a special cut that makes them unusual.

A good way to shoot these items is to lay them in an S-shaped curve. This may mean crumpling a portion of the middle section to make the whole piece fit the frame. Shooting from a low angle helps. Composing so the near part of the work fills the bottom of the frame, while letting the rest of the piece flow up and away from the viewer, makes a stronger image and solves two problems at once: The photo will show a detail in the near end; and the S curve helps communicate both the size and feel of the material.

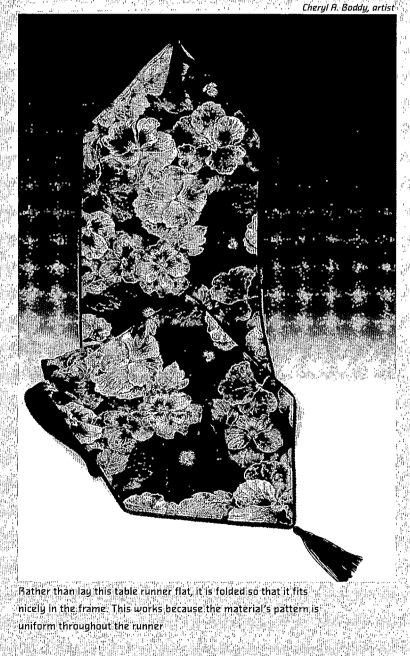

Cheryl A. Boddy, artist

Rather than lay this table runner flat, it is folded so that it fits nicely in the frame. This works because the material's pattern is uniform throughout the runner

This is one of my black-and-white exhibition prints. The photograph is about 6 x 9 inches (15.2 x 22.9 cm) and the frame is about 16 x 20 inches (40.6 x 50.8 cm). The print inside the frame looks too small when photographed this way.

Photos of Photos

With art photography, I often ask myself what is more important: the image itself, or the mounted and framed print?

When the complete package is the subject, for instance a photo for someone who sells framed pictures at art fairs, the frame needs to be in the picture. But, as you can see from the example of a framed photograph, the picture can get lost when there's more mat than picture in the image. This black-and-white photo should be seen close up in order to observe all the detail. If this were a rosy and blue sunset, where color is more important than detail, a photo of the whole picture and frame might work better.

When the photographic image itself is the subject, I think that showing a small portion of the mount-board or frame tells the viewer that this is a picture of a print, not an unprinted image of a scene. When there is no framing material showing, I consider the photo to be an image rather than a printed, matted, and mounted photograph.

Sometimes the important aspect of the photograph is its size. Big, impressive photographic prints need to be shown as big and impressive. Scale matters. To show this type of scale, other elements in the image have to give a sense of the work's size. For very large prints, it is a good idea to shoot

By coming closer to frame just a portion of the mat surrounding the print, I make the photographic image bigger and easier to see. The bevel edge of the photo mount is visible, telling the viewer that this is a photograph of a photographic print.

the work in a room-like setting. You don't have to shoot the whole room, but showing a piece of furniture or a window edge demonstrates scale, telling the viewer that this is a large photographic print that works as a decorative element in the room.

When the objects I am shooting are photographs, I approach the lighting as if I am shooting two-dimensional paintings. Start with two matched lights placed at equal distance and to either side of the photograph. Check the lighting exposure carefully to insure uniform coverage of the light. Glossy photographs are sometimes shiny enough to have hot spots, but these can mostly be eliminated by positioning the lights closer to the plane of the photograph.

Daguerreotypes were among the first photographs. They were made by coating a metal plate with a light sensitive emulsion. The image is a negative that must be viewed against a black background surface. The metal is very reflective and appears as positive only when viewed from the correct angle. The trick to photographing this daguerreotype was to cut a hole in a black cardboard card and put my lens in the hole. The lighting was a standard setup with two equal lights.

04

photographing three-dimensional objects

● ●

T he photography of three-dimensional objects builds on the principles used for setting up and lighting two-dimensional pieces. Start with the basic studio setup (page 50) and build from simple to more complex lighting. Three-dimensional pieces are all about shape, and recording the strong shapes found in these objects requires the proper form of lighting. Some shapes are photographed best with a single overhead light, others with two lights, and others with three.

Instead of putting this panel in the center of the frame, I positioned it to the left and angled it along a diagonal to give it a sense of motion.

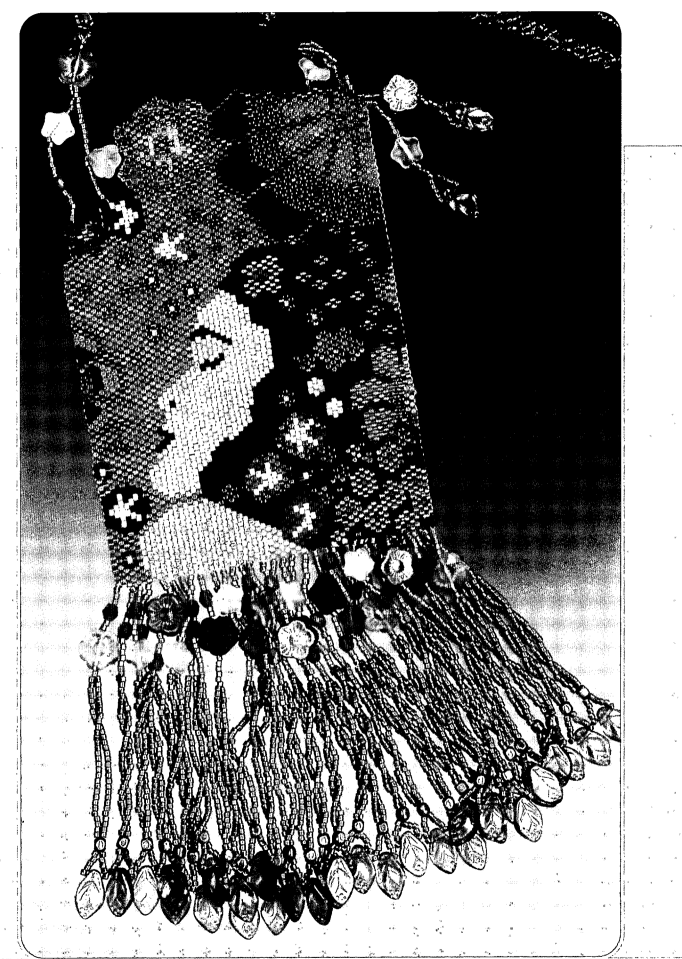

Jennifer S. McLamb, *artist*

| thirds | diagonal | s-curve |

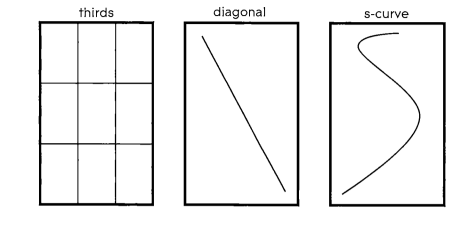

Compositional Shapes

Composition

Composition is the arrangement of the elements in a painting, a musical score, or a photograph–any piece of art–to create impact and meaning. When photographing objects, the photographer's responsibility is to use composition to animate and give visual energy to the piece of work.

Digital frames are rectangular in shape. In such a space, it is often best not to position a subject in the middle of the frame, which is exactly where most people place it in their photos. (Most cameras have some sort of focus markings in the center of the viewfinder, and I think folks think that this is where they are supposed to place things.)

Dividing By Thirds

For rectangular or square images, there are several basic compositional devices that work well. The most significant is the rule of thirds. Whenever you take a picture, imagine a grid of lines crisscrossing the viewfinder or monitor frame like a tic-tac-toe diagram. There are two lines that cross the frame vertically to divide the frame by thirds, and two that cross the frame horizontally to divide the frame into thirds again (see the left-hand image of illustration). Use these imaginary lines as a guide for positioning objects.

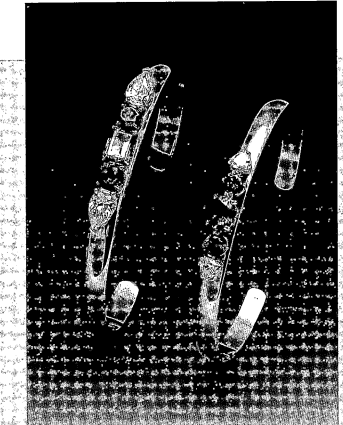

Lynn Buehler, artist

Using the rule of thirds usually leads to stronger compositions.

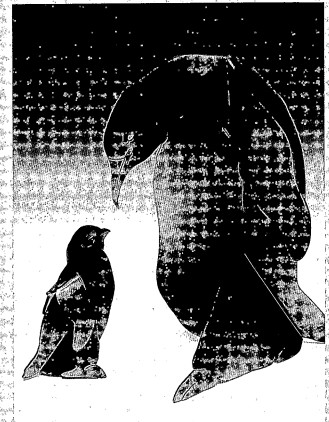

Dawn Mickel and John Gardini, Black Cat Enterprises

To illustrate this idea, the two bracelets in the photo above divide the composition into vertical thirds. Not only that, but they are sitting on an imaginary horizontal line that cuts across the bottom third of the frame while reaching up to the top third of the frame. The middle is empty.

In the picture of the penguins, the two birds are placed on lines that divide the frame vertically. The chick stands along the left vertical third and is anchored to the lower horizontal third line. The mother's body is on the right third vertical line with her head on the top horizontal third line. Once again, the action is all around the middle of the frame, but nothing of importance appears in the center of the picture. Composing a photograph so that all the image elements follow the rule of thirds gives the picture more interest and visual energy.

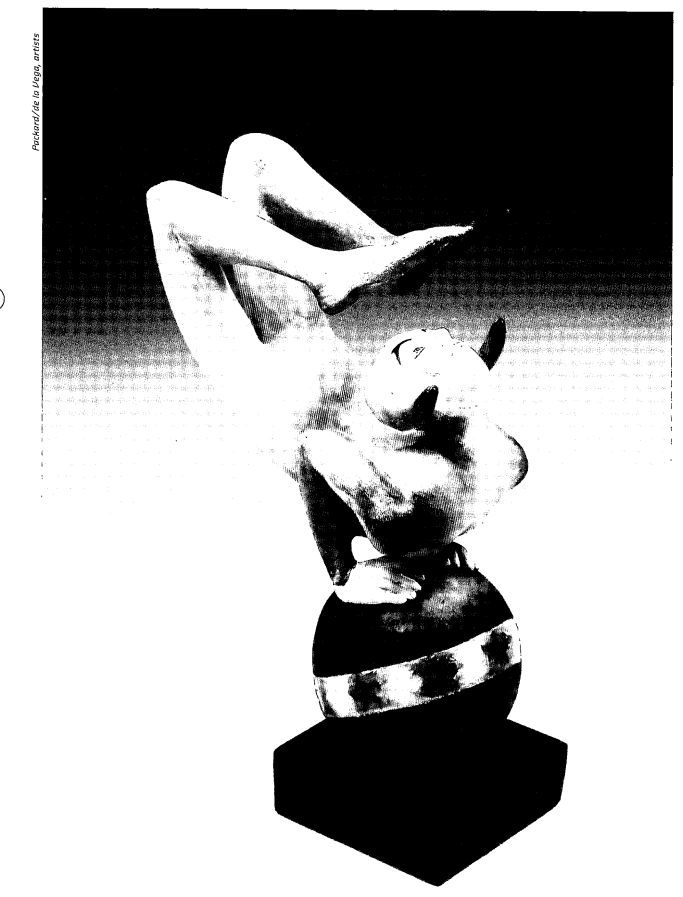

This papier-mâché circus acrobat is balancing on a strong diagonal line formed by his torso. The face and right edge of the figure are along the right vertical line of thirds.

Diagonal Lines

Look for lines that run diagonally when you compose a photo. They draw our eyes into a picture and lend energy to transport us through the image. Like the S-curve described below, digonals take us from the entrance of the frame to some point of importance within and hold us there.

The photo of the acrobat balancing on a ball illustrates the use of two compositional principles working simultaneously. The body is photographed so it's primary postion lies along a diagonal that starts in the upper left corner of the frame and flows down toward the right corner. Meanwhile, the acrobat's head falls on the right line from the rule of thirds and the ball is below, also on the right third. The figure's legs sit within the top third of the frame, neatly utilizing the rule of thirds.

S-Curves

Another useful compositional arrangement is the curving S-pattern. It resembles a river that usually meanders through a landscape. It's a sensuous line that is usually more appealing than a straight one.

The smooth curve is a natural for subjects that have a feminine side. The beaded necklace is laid out in a S-curve. The necklace wouldn't have been as interesting laid out as a circle or loop, but with a curve it has energy. The S also allows the necklace to fill the frame better as a diagonal composi-

tion. Weight is added to the image because the sides of the necklace are concentrated close to each other. With the necklace shaped as a thin curve, it takes less space within the frame than an open loop, allowing me to get closer to the necklace and showing more detail in the resulting picture.

Beth Russo Jewelry

The gentle curve adds visual interest to this necklace. One's eye enters the frame at the top near the clasp (the point of highest contrast) and then follows the chain down to the pendant.

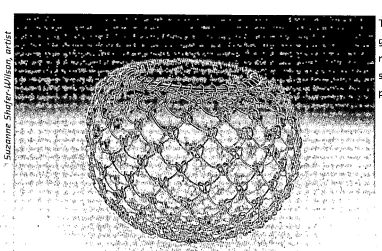

The simple graduated background used for this photo makes it hard to tell the size of this hand-made copper woven basket.

SCALE

Backgrounds take on added importance in the photography of three-dimensional objects because they help to isolate the work in space and focus attention on its form. But objects photographed on a featureless background lose their scale. Without a point of reference, it's hard to determine an object's size. This scale may not be a big problem with familiar objects like a diamond ring, a wine glass, or a woman's purse. But sometimes objects are outside our normal experience, and we have no way of knowing how big or small they may be. The copper woven basket sitting by itself on a background offers few clues to it's size. As soon as I hold a similar basket in my fingers–providing a point of reference–the viewer instantly knows just how small one of these pots actually is.

If the size of an object is important, be creative with how you show scale. Try thinking of something that naturally goes with the object, for example fingers holding a tiny basket or a flower placed in a vase. Sometimes photographers insert things that don't belong to indicate scale in pictures: memory cards, eggs, dollar bills, and even yardsticks. These objects are distracting and cheapen the look of a nice antique or piece of art.

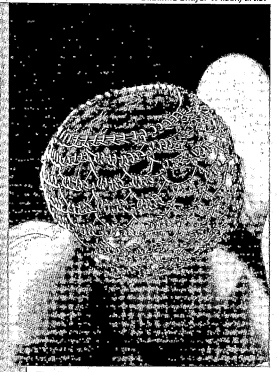

The fingers holding this copper wire basket give a point of reference for scale, demonstrating the object's small size.

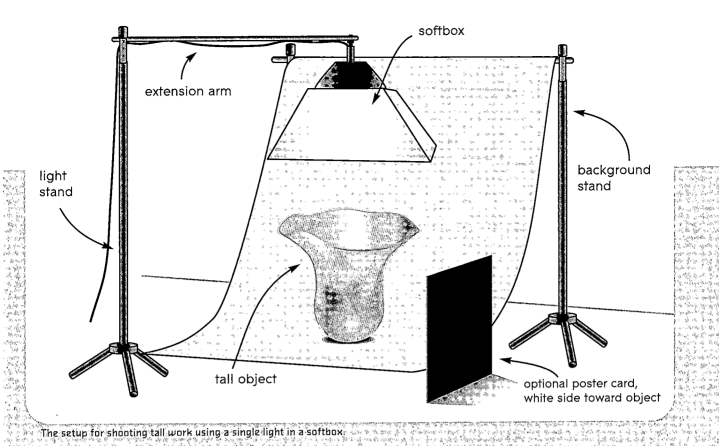

extension arm

softbox

light stand

background stand

tall object

optional poster card, white side toward object

The setup for shooting tall work using a single light in a softbox.

No matter what you are photographing, remember the need to use strong composition. Be creative and keep your eyes open for examples of these compositional forms so you can incorporate them when you shoot. Do your best to fight the tendency to have everything in the center of the frame.

Ceramics

The form and surface of the work are the most important concerns when photographing ceramics. There are at least three groups of shapes: tall objects like vases, shorter thick objects like bowls, and flat objects like plates. To complicate things, within these groups is a range of surfaces, from very matte to shiny glazes. Getting the light placement and light quality right is dictated by which combination of these factors is involved.

Tall Objects

Tall objects like vases and pitchers are best photographed using a single diffused light source suspended over the subject and a graduated background. I use a fabric softbox poised over the work on an extension arm for this type of photography to get a diffused, broad light. Suspending the light creates a pool of light at the bottom of the frame that helps accentuate the height of the object. Since the softbox directs most of its light downward, very little light bounces off the background to illuminate the sides of a tall work. To compensate, I place a piece of white poster board on one or both sides of the object to serve as a reflector, bouncing light into the side of the work, as shown in the illustration above.

Ann Darling, artist

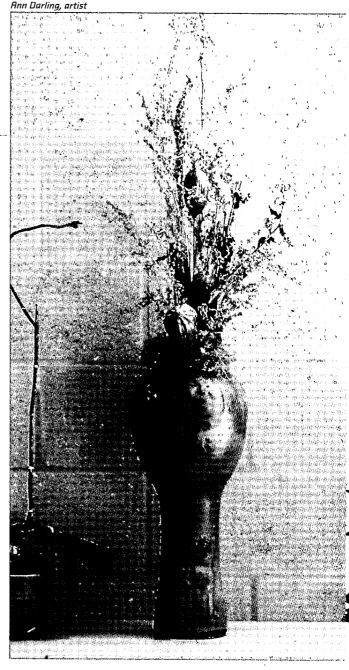

To find the correct exposure for a setup involving tall pieces, take a reading from the center of the work. With an overhead light, the top of a tall subject is closer to the source and will receive more light than the body. When I take an exposure reading from the center of the piece, the top rim will be highlighted in the photo. This not only looks pleasing, but it helps to separate the top of the work from the darker part of the background.

Overhead lighting works as long as the diameter of the rim of the object is smaller than the diameter of the body—in other words, the object is skinnier at the top than it is in the middle. If the reverse is the case, the top casts a shadow over the work, you will probably need to use a different lighting arrangement, with lights placed on either side of the object. The use of overhead lighting for taller pieces is usually a good idea, but it is not set in concrete. Experiment with lighting positions to meet the needs of a particular object. For example, when shooting glossy ceramics, glare can sometimes be reduced by moving the overhead light back towards the background.

Rules for composition definitely help make better photographs. But sometimes breaking the rules can still produce an interesting picture. This ceramic vase was photographed with natural light against a light brick wall. It sits right on the middle line of the frame, and there is a second, unrelated, object at the extreme left of the frame. Yet somehow the image still works to convey a feeling for this piece.

A two light/two umbrella setup is used to shoot most short pieces. The light on the left side of this bowl and cup was placed closer to them than the light on the right side, as evidenced by the slightly darker shadows that fall to the right. This adds a sense of dimension to the pieces.

Short Pieces

Short, round pieces like bowls and plates are best shot using a standard two-light tabletop setup (see page 113). How the lights are modified depends on the piece's surface texture. Simple reflector-housed lights work well with unglazed clay, while moderately glossy glazes can be shot with umbrellas, and higher gloss glazes may call for softboxes or a light tent. First, decide which elements of the work you want to emphasize. For instance, with a ceramic bowl, you could ask whether its interior decoration or its shape is more important. If the interior is the dominant feature, then the object should be photographed from above at about a 45°angle so we see the entire rim and much of the interior in the image.

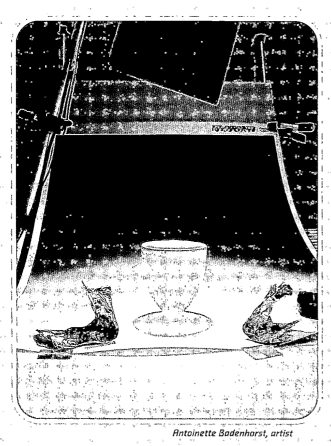

Antoinette Badenhorst, artist

A spotlight is focused into and through this translucent porcelain bowl. The camera is almost at eye level with the work because it is less important to see the interior of the bowl than to show the exterior surface decoration.

This setup shows the way a similar porcelain bowl was photographed. The folded aluminum foil reflectors throw sparkling light onto the sides of the bowl. The card at the top was attached to the spotlight to keep light from spilling into the camera lens.

When the shape of a piece is most important, take a different approach. Start by lowering the camera until it is barely above the table top. The back rim and the interior of the bowl won't be visible when shooting from this low angle, and such an extreme profile is generally not a very pleasing view. So slowly raise the camera and watch as the back rim and interior become visible in the viewfinder. At some point you'll find a camera height that works best. I usually create an image with most of art piece's rim visible along with a touch of the interior.

Antoinette Badenhorst, artist

Limoge is famous for it's porcelain plates. This one celebrating Napoleon Bonaparte was photographed with two floodlights bounced off photo umbrellas. The light is softened, but not so much that it weakens the colors in the portrait. Finding the quality of light that enhances the work's surface is the photographer's main task.

Ceramic Plates

Bowls and other curved subjects with shiny glazes always have hot spots that are simply reflections of the lights. A little shine is a good thing because it shows the viewer that this is a glossy surface. But too much glare washes out large areas of the object. As always, the remedy for glare is to soften the quality of the light and to reposition the lights as needed, away from the subject.

Boxes, though not round, are similar to bowls since they are short and squat. Square or rectangular objects are best shot at 3/4 profile with the camera above the object at a 45° angle to the table top. This shows two sides plus the inside of the piece.

From flat, matte unglazed clay to the super gloss of low fire metallic glazes, ceramics have perhaps the widest range of surfaces. This means you should learn how these surfaces differ in order to shoot the best photos of each. But no matter what type of surface, the decoration or texture on a plate is almost always its most important feature.

Start with the basic studio setup shown on page 50. Stand a plate on its edge using either a plate holder or something out of sight behind it. The plate will lean back a little in either case, so make sure to carefully set the camera parallel to this angle. I center the plate using the focusing/exposure markings in the middle of my viewfinder. Try both horizontal and vertical compositions to see what works best.

Ceramic Surfaces

Start by placing lights equidistant on both sides of the plate at about a 45° angle. If unacceptable hot spots appear, move the lights toward the plane of the plate as needed. With dark plates against dark backgrounds, consider a single-light setup with the illumination suspended above the plate and to provide a rim light that will separate the plate from the background. If needed, use reflectors on either side of the plate to lighten dark areas on the plate's surface. See more about shooting plates in the section on glass plates (page 105).

Matte surfaces often need to be punched-up because they usually photograph as flat and lifeless. The lighting needs to be fairly hard, the kind produced by a light in a reflector housing. This also produces deep shadows behind the work, and these in turn need to be lightened either by moving the fill light (on the side opposite the main light) towards the background, or by using a reflector to bounce light in from slightly behind the subject.

Multiple layers of glaze make the surface of this salmon shiny and reflective. It required extreme softening of the light.

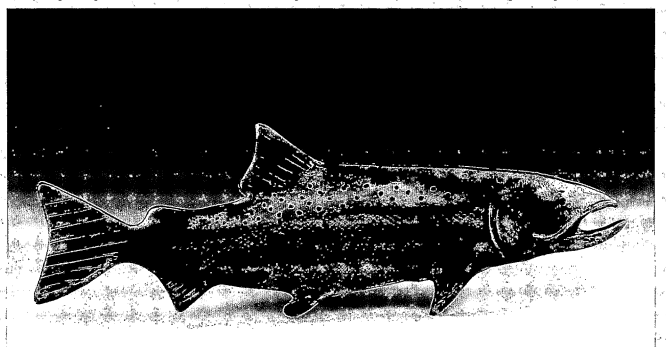

Ainsley Walden, artist

Shiny glazes present a different challenge—glare and hot spots. As discussed earlier, there are a couple of ways to reduce glare (see page 76). Be careful not to totally eliminate glare because it helps reveal the object's surface as well as making it easier for the viewer to see curves and forms. The ceramic salmon in the photo on the opposite page is extremely shiny. Its curved and textured surface made it impossible to eliminate glare by moving the lights or using a softbox. My first thought was to put the work in a light tent on a table top, but I still got large hot spots when I tried this.

To soften the light and get the results I wanted, I turned my floodlights around and bounced them off white umbrellas into the light tent. This reduced the contrast of the light considerably and almost totally eliminated the glare. The double softening worked, but the price was the loss of four to five stops of light. Tungsten lights simply didn't have the power I needed in this situation, so I had to switch to my studio electronic flash units.

For this life-sized, super glossy ceramic dog, I had to turn my whole studio space into a light tent by hanging white bed sheets all around. Several lights pointed at the pooch were placed outside the sheets. I shot the picture through a hole cut in the front sheet

Barry R. Cohen, artist

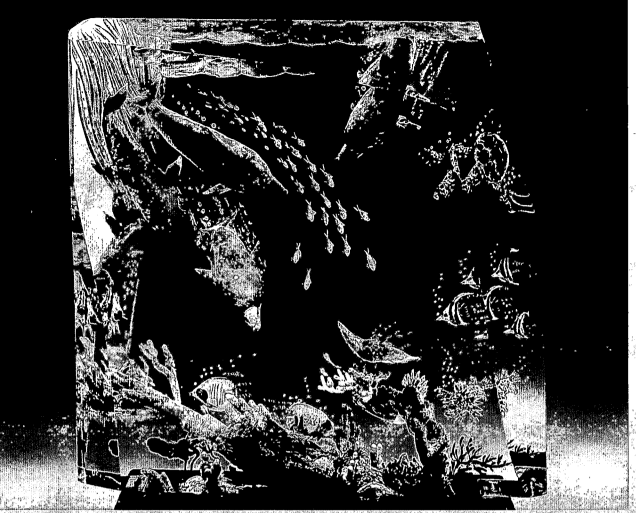

This is a classic example of highlighting. This acrylic aquarium was placed on a stand in front of a dark background. The main light was positioned behind the piece and pointed at it. A large white poster board was positioned to the right of the piece to throw some light on the front surface of the aquarium.

Glass and Acrylics

Glass objects are harder to photograph than ceramic ones. Not only is light reflected from the shiny glass surface, at the same time it is also transmitted through the material. This adds complexity to the photography. However, digital cameras have come to the rescue, making photography of glass easier than it used to be. Now I can see the images on my LCD monitor and make corrections to re-shoot immediately.

Note: Translucent acrylics are photographed like glass, and the methods explained here apply to them too.

Tall Glass

Highlighting and silhouetting are the traditional techniques for photographing tall glass subjects, like wine glasses, vases, or any object that's taller than it is wide and has a large amount of (mostly) clear areas. Highlighting, or some variation of it, is the most usual method. The standard approach is to light the object from underneath or from behind against a black background. One technique is to position the subject on a glass sheet suspended over a light source: Place a large pane of glass about a quarter inch (.64 cm) thick on top of two stacks of books that are 18 – 24 inches (45.7 – 61 cm) above the light source. Both the light and books are outside the picture frame.

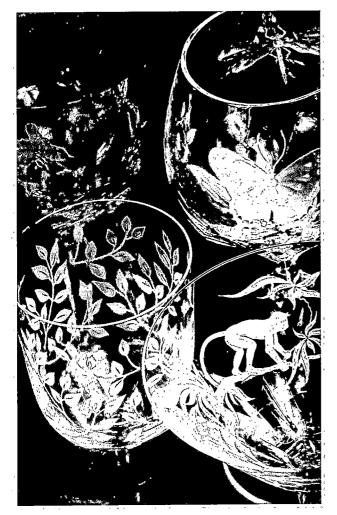

Hang a black background behind this setup. To block the light from spilling onto the background, place poster board between the two piles of books on the background side of the setup. Then put the subject on the glass pane and lower the camera to the level of the pane so the subject is in profile. Turn on the light, take an exposure reading off the subject, set your camera, and shoot. I check the monitor to make sure the background is black and the glass is highlighted. The glasses in the photo at left were shot this way, except I raised the camera to produce an interesting angle instead of just a profile.

In this example of highlighting, the glasses were placed in front of a black background and lit from above by a single light bounced off an umbrella. This is an excellent way to emphasize etched surfaces.

Kathy L. Watson, artist

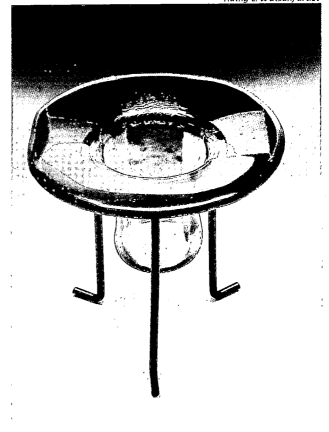

A single softbox suspended over this solid blue glass was all that was needed to highlight this piece.

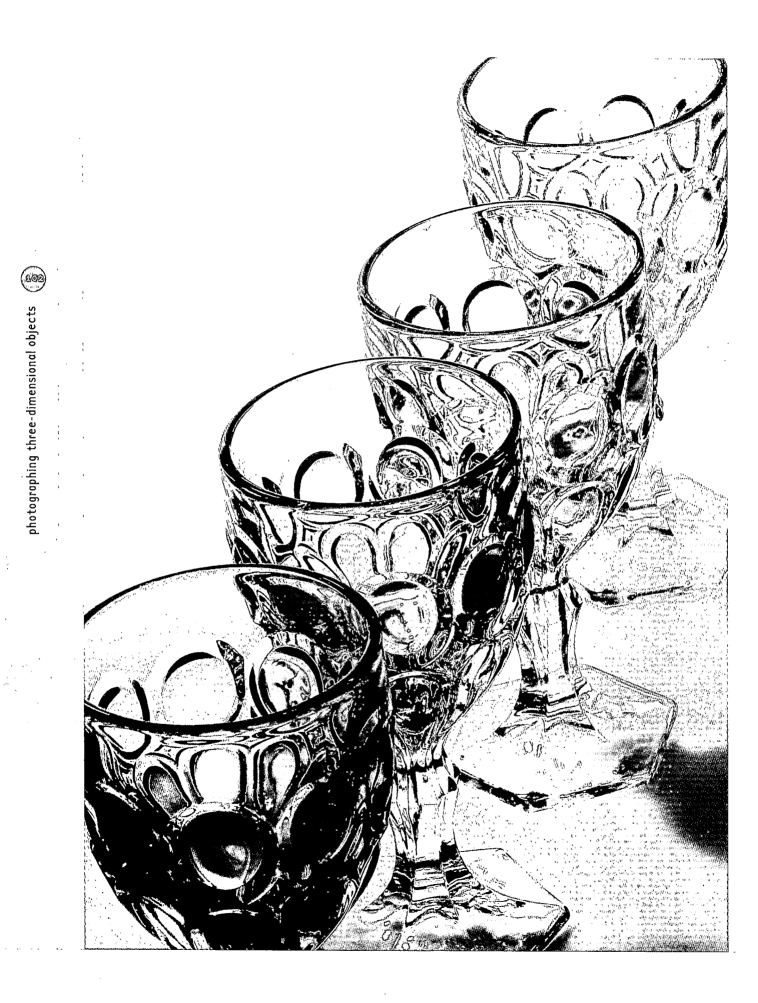

In this example of silhouette lighting (left), the light is pointed at the white background and the glasses are seen in outline. A large white reflector was placed to the right of the glasses to brighten the overall image.

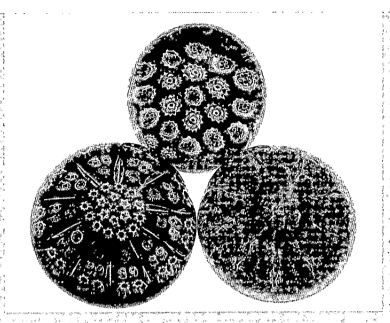

An alternative method for highlighting is to use a single light above the piece. Placing the light source in a softbox to diffuse and soften it is important because glass is hard-surfaced and is highly prone to glare and reflections. Reflector panels can be placed on either side of the subject as needed. Always check your pictures in the LCD monitor to see if any parts of the setup are visible as reflections in the piece's surface.

Silhouetting is a lighting method that emphasizes the form of a piece. Silhouetted glass pieces are dark shapes outlined in front of a light background. (Highlighting is the opposite, emphasizing the surface of the glass and its edges by presenting the glass as a light subject against a dark background.)

To make a silhouetted image, place the glass object on a light colored background so there is some space between the object and the vertical portion of the background. Point the main light at the background, which will leave the glass dark against the light background. Take an exposure for the backdrop, then set the camera to let an additional 1 to 1-1/2 stops of light reach the sensor. If the background reading is f/16, set the camera aperture to f/11 or to halfway between f/11 and f/8. I want the background to be totally white when checking the image in Playback mode on the LCD. If the glass itself is too dark, I may use a reflector card to put a little light onto the front surface of the glass.

Short Glasswork

Short glassworks with thick round shapes, like bowls, are also usually photographed with light coming from under the object. A light box for viewing transparencies can come in handy. I used mine for the photo of the paperweights above. I arranged them on the light box and placed a second light over them to fill the shadows on the portions facing the camera.

A photographer's light box makes photographing these glass paper-weights easy. Notice that a Lowel EGO is suspended over the light box as the second light source.

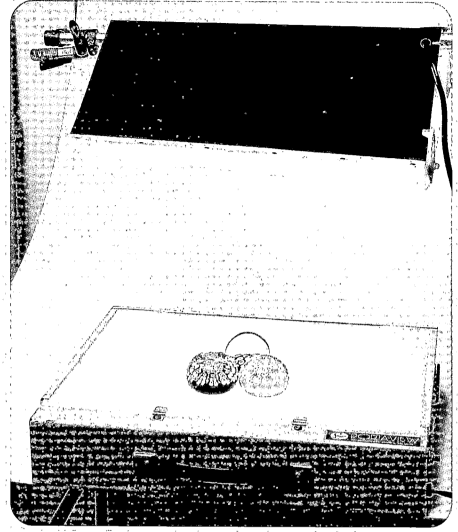

If you don't have a light box, you can create a similar device by replacing the glass pane (set on book stacks described earlier) with a white or frosted piece of translucent glass or plastic.

To get the right exposure for this setup, I take a reading on the light box and open the aperture setting by 1-1/2 stops. The camera's multi-segment metering mode works well for this job. The idea again is to have the background be pure white with no texture. The trick here is to adjust the second light so that its exposure reading is the same as the aperture setting on the camera. For example, if the light box reading is f/16, I set the camera's lens aperture to between f/8 and f/11. Then I turn off the light box and raise or lower the overhead light until I get this aperture reading (halfway between f/8 and f/11) as my exposure reading. Sometimes with lighter colored subjects, a simple white reflector card held over the subject is sufficient to lighten a dark area.

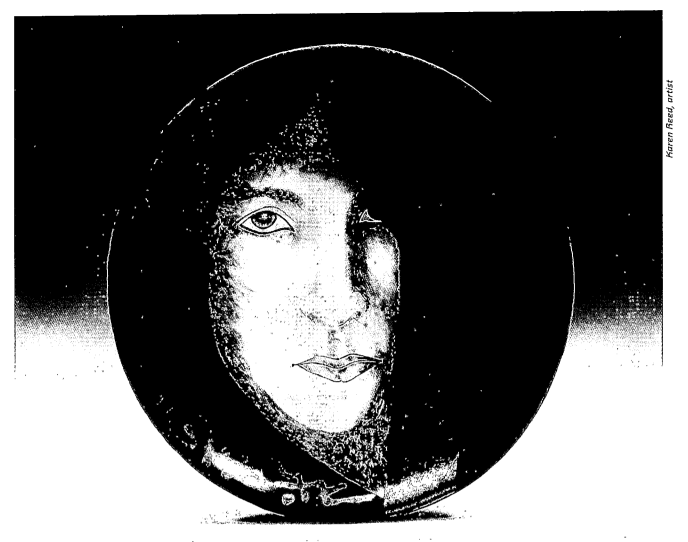

Glass, ceramic, and metal plates are all shot in a similar manner. The lights are placed on either side of the plate and adjusted for the best exposure. With this dark piece, the two lights are almost directly above the plate with a reflector placed in front, to lighten the face. Although plates usually require a plate stand, this one had a foot that I could lean against a heavy can so it remained upright.

Glass Plates

Translucent glass plates are photographed using split lighting: The main light is placed above and behind the plate and the fill light is in front. Remember that the main light creates the highlights. Placing the light behind the plate pointing towards the front pumps light through the piece, lighting the colors and form of the glass. This creates a shadow in front of the piece. So I turn on the front fill light and move it until the shadow becomes lighter and the front surface is properly lit. In other words, I adjust the lights until I can see an exposure difference between the two lights that looks right. Usually this turns out to be about 1 to 1-1/2 stops in intensity.

I shoot translucent plates against a dark background (or dark portion of a graduated background) so they will stand out from the background. To stand plates up, use clear plastic plate stands. Center the plate and take an exposure reading using the camera's metering system (I like to use center-weighted). Shoot a frame using the resulting exposure and check the image in the LCD. If the plate is not properly exposed, adjust the aperture accordingly and take another exposure. Check the LCD again to see if the aperture adjustment results in improved exposure.

Note: If the glass piece is not translucent, use the basic two-light studio setup, but follow some of the suggestions here for getting the correct exposure.

This uniquely designed stained glass lamp was shot with its internal light turned on. A small floodlight bounced off the ceiling and lightend the exterior. For techniques to photograph other objects that light up, see page 127.

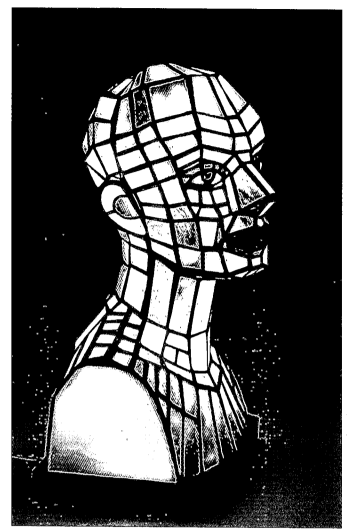

An Cantor, artist

Stained Glass

Photographing stained glass requires an approach that is a variation on silhouetting (see page103). The piece of stained glass is a few feet in front of a large white or light colored background. The main light is pointed at the background rather than the subject. This will bounce light off the background and send it through the stained glass, lighting the glass. A second light placed in front of the piece at a 45° angle is used to fill in the front surface texture. The trick is to experiment with the position and the intensity of the two lights until you get an exposure that accurately records the shape, texture, and colors of the work, not just masses of different colors.

Start by taking an exposure reading from the front of the stained glass and take the picture. Check the LCD monitor and adjust the aperture or shutter speed as necessary. The lighter areas of the work should be bright and retain detail. And there has to be some light coming through the darker glass pieces so that detail shows there as well. Very dark stained glass is often too dense and too dark to allow light through. This means that while the lighter colored glass may look great in a photo, the darker portions may appear black and lifeless. Sometimes the contrast range within a work of stained glass can be so great that there isn't a good way to get a decent photo.

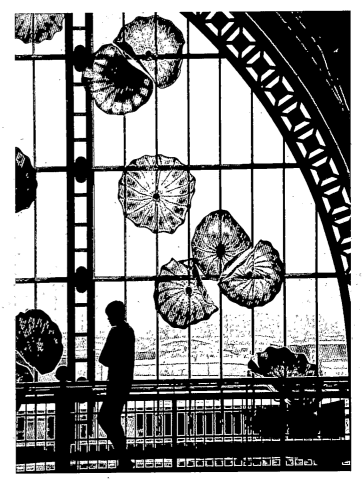

The stained glass bust illustrated on the opposite page is an unusual piece that demonstrates how to effectively shoot stained glass in the studio. Since the bust itself is a light, the glass wraps around a light source, e.g. the internal bulb, that becomes back light. The first task is to turn on the piece in a dark room and get an exposure reading of the light coming through it. After turning the bust off, I turned on tungsten studio lights and moved them until I got an exposure reading about two stops lower than from the bust itself. Then I turned on the piece, took a photo, and checked it on the LCD monitor. A good photo of stained glass shows the colored glass, light coming through the work, and the texture of the front surface of the glass.

Obviously I can't bring stained-glass windows from a church or public building into my studio, so I have to travel to shoot these pieces. Sometimes the height of these causes a problem because pointing your camera up can create a distortion in the window's shape called keystoning. One way to correct keystoning is to use tools found in many image-processing programs (see page 135).

It's best to shoot stained glass windows on a day that is overcast with diffused light so colors in the window record more accurately. On bright days, sunlight can pour through windows and wash out the lighter colors, or the color temperature of a blue sky can cause the colors of the glass to take on a cast that may be difficult to correct. Because interior building lights, both fluorescents and tungsten, will add color casts to the photograph, it is best to turn them off.

This pendant is made of multi-hued blue dichroic glass. It took several tries to find the best setup for this piece. I finally used a broad softbox over my light to fill the entire surface of the pendant.

Susan Goracy, artist

Dichroic Glass

Dichroic glass reflects an ever changing rainbow of color. However, it's difficult to capture that rainbow in a photographic image. The broader the light (less directional, more diffuse), the more colors will be reflected by the dichroic material, so I shoot these pieces either placed in a light tent or lit by very large softboxes. Because these objects require the use of softboxes and reflectors to create broad light sources, the issue isn't glare, it is finding a way to gete the surface to sparkle. Keep an eye on the total surface as you set up your lighting and bounce light into dimmer areas to get the whole dichroic surface to sparkle.

Once the setup is complete, I take the time to study the work from different angles to find one that produces the best color. This is usually tricky because once a particular section is attractively illuminated, another section often loses its brilliance. You can find a rich red tone in one portion of the piece, only to see the beautiful blue in an adjoining surface go dark. Each dichroic object is different and will require experimentation.

Robert Giordano, artist

You must capture the form of a sculpture in your photos. A black background creates a powerful frame for this metal tube sculpture. Its bright colors separate it from the backdrop and the sharply cropped framing creates a visual center around the yellow inner ring.

Packard/de la Vega, artists

I often light sculpture as if I was shooting a portrait, which is how this one was done. In addition to using a main light in a softbox and a reflector to create soft shadows, a spotlight was placed behind the piece and aimed at the juggler's hat. In portraiture, this would be called a shoulder light.

Sculpture

Sculpture is three-dimensional form, and you have to emphasize the lines, shape, depth, and features of the sculpture when shooting these types of pieces. That means you will need to experiment with the lighting to deal with the unique aspects of every piece of sculpted art.

Start with the basic two-light studio and work with the lights to bring out the shape of the sculpture, as shown in the example of the papier-mâché juggler. I lit it so there is a slight shadowing under the chin and on the right side of the nose. These shadows define the figure in three-dimensional space. The figure was photographed with a single light in a softbox about three feet (.92 meters) in front of the subject and to the left. A large poster-board reflector was placed on the right side of the figure to soften shadows. Then, realizing that the figure wasn't really popping off the dark background, I added a spotlight behind and above the figure to light the juggler's hat.

photographing three-dimensional objects

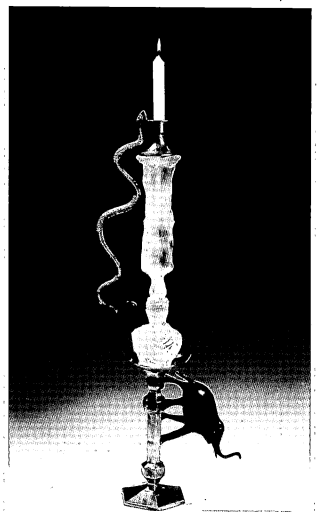

I needed to use a long exposure for this mixed media piece in order to capture the candle flame. A floodlight to the left of the subject was dimmed so it would not overpower the flame.

The mixed media and glass candlestick in the photo at left illustrates a sculpture piece that is difficult to light effectively. It required a combination of lighting methods, yet the whole idea was to make this complex piece look natural.

For this piece, the main light was in a softbox positioned above and slightly behind the piece. Facing the subject, the fill light (also in a softbox) was placed above the work to the right, opposite the main. It was set to one-half the intensity of the main light. A white reflector was positioned to the left in front of the subject. I turned off the studio lights and took an exposure reading of the candle: 1/4 second at f/11. I then turned on the studio floodlights and adjusted them to get a reading of f/11 at 1/8 second from the area around the elephant (I used the camera's spot meter for the readings.)

With the camera in Manual (M) exposure mode, I set the lens to f/11 and the shutter speed to 1/8 second and took a photo. The image seemed a little washed out, so I tried another frame at 1/15 second that was right on the money.

Don't be afraid to experiment at any time with different methods for lighting, different lighting placements, different camera angles, or different camera settings. You can always delete pictures that don't show the results you like.

This sculpture, The World Divided, is lit by a softbox placed behind and to its left, with a silver reflector positioned in front and to its right. The backlighting adds drama to the image, making the front surface of the cleaver dark and menacing.

Len Vincenti, artist

Wood

Nearly all woodworkers will tell you how important the "touch" of wood is. That sense of how the wood feels lies at the core of the woodworker's art. Every type of wood has its own nature and texture. From the grain patterns to the location of knots, no two pieces of wood are the same. So usually when photographing wood, the elements of surface quality, patterns, and shape are the main issues. Which elements are dominant in a particular piece, and which are subordinate?

The basic techniques for photographing wood are similar to those for photographing tall and shorter ceramics. They require adjusting the quality of the light, usually softening it to emphasize the surface of the work.

A single floodlight was used in a softbox suspended about 3 feet (1 meter) above and angled slightly to the left front of this wooden pot. Because the wood is light, the hot spot created by the lighting didn't burn out detail in the wood.

George W. Nichols, artist

A softbox was suspended directly over this wooden bowl to light the inside and create a rim-light that separates the foreground edge from the interior.

Richard Cruise, artist

For wooden bowls and boxes, I often use an oversized softbox, approximately 30 x 40 inches (76.2 x 101.6 cm) on an extension arm attached to a light stand. This provides a lovely soft light that emphasizes the wood's surface and texture.

With glossy varnished, lacquered, or polished wood, glare spots can occur. To reduce or eliminate them, move the softbox away from the piece. You can also move the softbox to different locations behind the wood piece to see if there's a place where the hot spot is less prominent.

Another way to reduce glare in polished pieces is to increase the overall light level. If the correct exposure for a wooden bowl is f/8, the exposure for the hot spot may well be three stops brighter–approximately f/22. This dynamic range is probably more than your image sensor can handle. By bouncing a couple of floodlights off of reflectors, you can raise the overall exposure of the scene, reducing the exposure range between the hot spot the rest of the bowl.

It is usually preferable for a little glare or small hot spots to remain. That helps communicate the object's surface quality and shape. Our eyes are drawn to the point of highest contrast, and that's the glare spot. You don't want glare to pull your eye away from an important area, but it is fine if it leads your eye into the qualities of the wood.

Note: Some people find it useful to use dulling or matte sprays to eliminate shiny spots and glare. While these effectively lower the shine, they give an unnatural look to the wood and create flat places that don't enhance your photographs. I avoid them.

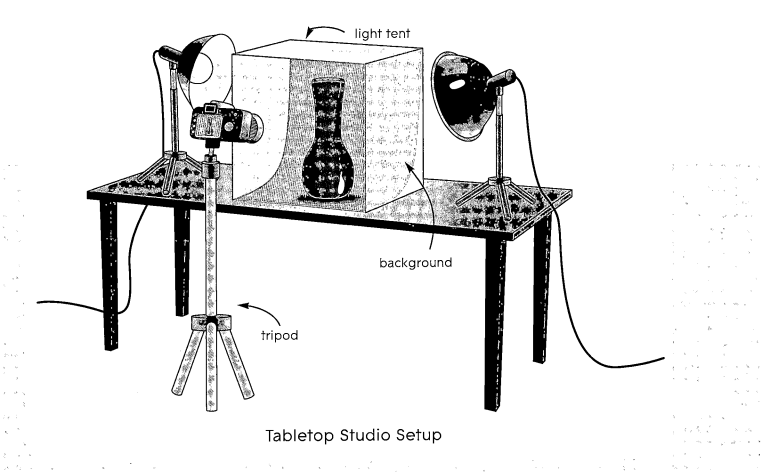

light tent

background

tripod

Tabletop Studio Setup

Jewelry

From the tight close-up of a gemstone ring to a photo-graph of a model wearing a long necklace, jewelry is an interesting photographic challenge. It is both tricky and rewarding work. The variety of materials used to make jewelry means there is no simple cookbook recipe to shooting these pieces. Be prepared to solve problems. It is common for separate elements of the earring or necklace to require differ-ent lighting, for example a dark stone mounted on a polished metal surface. The surface requires soft lighting while the stone should receive hard, crisp light. Invariably you will have to adapt and modify your approach to fit the work in front of you.

Photographing jewelry requires a tripod and, for most sub-jects, a camera with macro/close-up capability. Except for pieces worn by models, you'll need a tabletop setup and often a light tent for pieces with shiny surfaces.

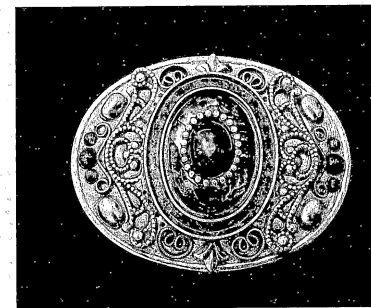

Michal Golan, artist

A solid black background makes a striking setting for this pin. It works, in part, because the matte metal of the pendant does not reflect the back-ground color at its edges.

This long, thin necklace would get lost in the background if laid flat in a circle. By wrapping it around itself, I could bring the camera close to clearly show all the elements of the necklace. This composition also makes a much more interesting pattern than a single circle.

Bess Heitner, artist

Necklaces

Necklaces fall into two groups: The first includes pieces with elaborate pendants on simple chains; the second consists of necklaces with crafted chains that may or may not include a pendant. In the first case, the pendant needs to fill the frame, with perhaps only part of the chain included. In the latter group, the whole necklace (or at least most of it, in some cases) needs to be in the picture.

Of all jewelry pieces, necklaces are among the easiest to photograph because they are usually large. Use the basic tabletop setup and include umbrellas for necklaces with such non-shiny surfaces as rough metal, wood, or unglazed ceramics. With very shiny materials, put the work in a light tent with the lights aimed at the tent.

You can hang a necklace to shoot it or lay it flat on a surface. I prefer laying necklaces down rather than hanging them because I can do more with the image. This presentation allows me to find interesting angles to shoot, particularly if I pair the necklace with a set of earrings or other pieces. When you lay work flat, position the lights behind the work area (rather than above the flat surface shining straight down) so the illumination is directed along the length of the necklace.

I like to shoot necklaces with lenses of moderate telephoto focal lengths. Depending on the size of your sensor, focal lengths in the approximate range of 70 to 90 mm flatten perspective, making near and far elements of the necklace closer in size. With moderate telephotos, you can place the camera from 2–4 feet (.61– 1.22 meters) from the necklace, providing plenty of room to light it.

When the pendant on the necklace is the subject, I lay it on a background and look at it from different angles through the viewfinder to find the best perspective. Head-on shots are less interesting than ones from an angle, which possess more energy. However, at close distances, depth of field is very narrow and stopping down is crucial, especially for angled compositions. Be careful if using the macro setting on a point-and-shoot camera. Usually these settings use very wide apertures, and you'll need to experiment to make sure they produce sufficient depth of field.

If the pendant is on a crafted necklace–for example the double-strung pearl necklace at right–I position the piece so the pendant and a few inches of the necklace appear in the picture. The pendant should fill at least a quarter of the frame. Lowering the angle of view to shoot more from in front of the pendant rather than from straight above is one way to do this.

I use a somewhat different approach to photograph a necklace when all its components are equal–for example a necklace crafted of large blue beads. I lay the piece on the background and experiment by arranging it in interesting patterns. I curve it to the left, to the right, or bend it in an S until I get a pattern I like.

Once satisfied with the composition and the lighting, I take a picture and review it using the LCD monitor to decide if any changes need to be made. I may modify the light quality or rearrange the necklace, then take another shot to see if I've improved the picture. The ability to experiment is where digital photography shines. There's no cost for using extra film and no waiting for processing. Once again, with digital photography you can see results instantly and decide to make adjustments if needed.

Marta England, artist

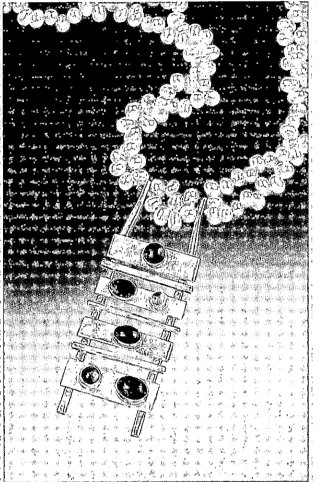

This pendant is beautiful, and so is the pearl necklace, so I wanted to show both in the picture. I created a diagonal composition (with a S-curve above) to add vitality to this piece.

Nick Nixon, artist

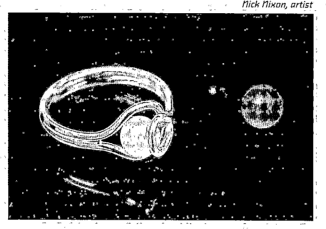

The glass support for this small ring acts as a mirror when a dark background is placed below, reflecting the ring and making the image denser. I photographed the ring with extra stones that can be exchanged with the one in the ring's setting.

I don't often photograph necklaces on models. Well-crafted necklaces should be photographed close up to give them impact, and you will be too close to see the model if you are close enough to see the necklace's intricate craftwork. Models generally sell an overall look rather than specific details. I use a model only if the necklace is made of large, simple elements that show up well even at a distance.

Marjorie and Dennis Collins, artists

This silver ring is only 1/2 inch (1.27cm) in diameter. The photo was made using an EVF camera that has a macro setting that allows me to focus close enough to fill most of the frame.

Earrings, Rings, and Small Pendants

These smaller pieces can be difficult subjects. And as the objects get smaller, difficulties are magnified. Tiny objects shot close up call for specialized gear and can test your ability. For good close up results when shooting small jewelry pieces, it is best to use a lens that focuses to within a few inches of the subject. A true macro lens for a D-SLR will give optimal results. A digital zoom lens is versatile and can often be effective if used in the camera's macro setting. But the close-up setting on many point-and-shoot cameras is for a fixed distance, not a continuous macro function. The lens may get close enough for a flower to fill the frame, but that's not the same as getting a much smaller piece of jewelry to fill the frame.

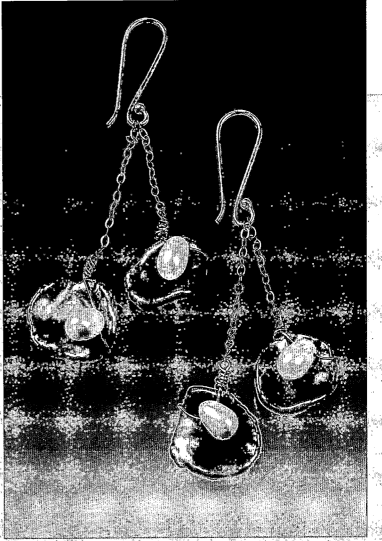

It also helps when shooting small pieces to use a macro tele-photo lens with a focal length range from 80 – 100 mm (rather than 50 or 60 mm). This usually gives between six and ten inches (15.2 – 25.4 cm) of working space between the lens and a small object, which allows you to light the front of the object without casting a shadow from the lens. (Built-in camera flash units and hot-shoe mounted accessory flashes should not be used in this situation because they will cast a shadow of the lens on the subject.)

This composition shows earrings placed at different levels, helping to fill the vertical frame while adding energy to the photo. Two lights bounced off umbrellas were used to produce a soft light with a little sparkle, complementing the muted surface of the earrings and pearls.

Always use a sturdy tripod when photographing small objects like rings and earrings. You will also want a small light tent to diffuse your lighting, which is essential for photographing shiny metals or dichroic glass. When shooting extreme close-ups, distracting texture can suddenly appear in what you thought was a nondescript background. That's why it is help-ful to use a very smooth surface as background, like vinyl, non-glare glass, metal, or tile.

I like to position earrings so that one is placed higher in the frame than the other. This is more interesting than leaving them side-by-side. As with glass objects, jewelry can also be put on a sheet of clear acrylic supported between stacks of books about 12 inches (30.5 cm) above the table top. This will make the pieces appear to float in space. Then I place a small piece of background material under the stack.

118

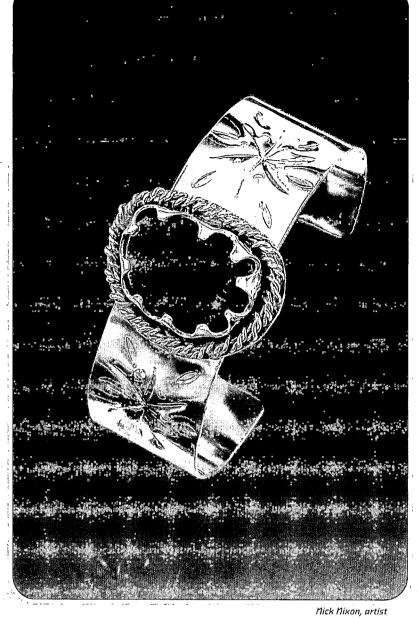

This shiny silver bracelet was photographed in a light tent with the camera lens poking through the slit in the front panel. The left light was closer to the tent than the secondary light, emphasizing the embossing.

Nick Nixon, artist

Jewelry with Shiny Surfaces

Objects with large areas of shiny metal are among the most difficult to photograph. What makes them so tough? First of all, the shiny surface acts as a mirror. And, if that surface is curved, it becomes a convex mirror that will reflect everything in the studio, including yourself. I photograph shiny jewelry in a light tent using a special technique with white cards positioned in the tent around the piece. The cards are held vertically with clamps and reflect back onto the silver surface, creating a texture that is easier to photograph while also keeping the crumpled fabric of the tent from appearing in the work. That's how I photographed the bracelets shown on page 89.

The camera's meter may overcompensate when it reads a bright scene like polished silver reflecting white cards, which causes underexposure. When using this white-card technique, you can experiment by adjusting your camera settings to let in more light. Take a test shot to confirm exposure.

Antiques and Collectibles

There are many reasons to photograph the antiques and objects that people like to collect, but two of the most important are for documentation and sales. Photographing valuables is a good idea for insurance purposes. And thanks to the popularity of web-based auction sites, the selling and trading of antiques and collectibles has become an international phenomenon. Good photos lead to additional sales, so it's advantageous to take the time to properly set up these types of photos.

Dolls & Toys

I try to shoot toys, especially dolls, from the viewpoint of a child. They should connect with the viewer on an emotional level. From their facial expressions, hand-sewn clothing, miniature jewelry, and other accoutrements, dolls are engaging subjects. I use a moderate telephoto or a zoom lens and photograph dolls as though I am shooting portraits of people.

Place a main light in front of the doll, a bit to the left or right. Then place a second behind and above the doll aimed at its shoulder, opposite the first. In portraiture, this second light is called a shoulder or hair light: Its purpose is to separate the subject from the background and highlight the subject's hair.

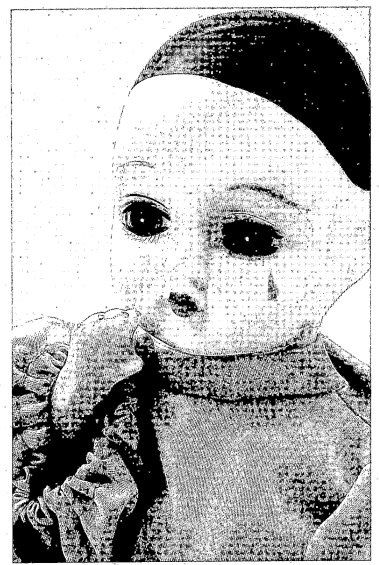

Try posing a doll to add interest to the photo. Here I placed the doll's hand at its face. A nice pose can help make an emotional connection with the viewer.

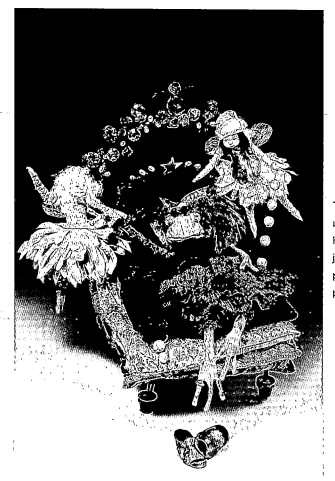

Marcia Peterson, artist

The frog princess and her fairy helpers were photographed with a single over-head light in a softbox. Since this sub-ject is playful, I arranged the frog's slip-pers in a crossing pattern to echo the position of her toes.

The main light creates deep shadows that emphasize the texture of the doll's features and clothing. These shadows are usually quite dark. To lighten them, put a white reflector on the side of the doll opposite the main light. The trick is to soften the light while keeping enough shadowing for good texture. Once I review the picture on the LCD monitor, I make necessary adjustments by moving the reflector until the doll's face looks as pleasing and natural as possible.

As in portraiture, the face is everything when determining proper exposure. So with the lights in position, I place the active metering area over the doll's face and torso. The doll's eyes are also important, so make sure to position them correctly. While looking through the viewfinder, frame the doll with its eyes looking into the camera's lens and placed along the top one-third line of the frame (see page 88).

I try to photograph dolls at eye level or slightly lower. Shooting from below adds presence to your subject. For round-faced dolls, I often employ a split lighting technique, turning the face toward the white reflector so the main light hits one side of the face. This leaves the other side of the face in shadow. If too dark, move the reflector closer to the doll or open the aperture a stop to lighten the face. Try it to see if you like the effect.

For toys, the choice of lens depends on the characteristic of the toy. Humorous or satirical toys are funnier when shot with the exaggerated distortion of a wide-angle lens, while telephotos seem to add importance to subjects.

The lighting for toys is similar to the other three-dimensional subjects. Backgrounds may well play an important role in toy photography. Though graduated backgrounds and spot-lighting can add dramatic focus and theatrically, toys are one of the few subjects where bright colored backgrounds work effectively.

Stamps and Coins

The techniques for photographing stamps and coins are similar to those used for paintings and other two-dimensional art, but on a reduced scale. Photographing these items at extreme magnification is particularly enjoyable because you get to see all the marvelous detail that went into their production, including the engravings and watermarks that are otherwise nearly invisible.

It is much easier to get good results photographing coins and stamps with a digital SLR or an EVF camera than with a point and shoot. You need a camera with good macro or close-up capability; one that focuses at 1:1, if possible. At this ratio the image of a dime covers an area on the sensor equal to the actual size of a dime. Few, if any, point-and-shoot cameras get this close. Some EVF cameras can focus at 1:1, but a D-SLR with a true 1:1 macro lens is you best choice for this type of photography.

Think of stamps as little paintings. In one way they are harder to photograph because they are small; but in another way they are easier because they are rarely shiny or framed. The stamp above with the Native American pot was taken with the diffuse light of an overcast sky coming through my window. While I generally don't use daylight, it can work with thin, flat subjects like stamps. Of course the camera was on a tripod with the lens set to macro and its smallest aperture. Using Aperture priority (A or Av) mode and multi-segment metering, I got the correct exposure right away. I also utilized the viewfinder grid display to square up the stamp.

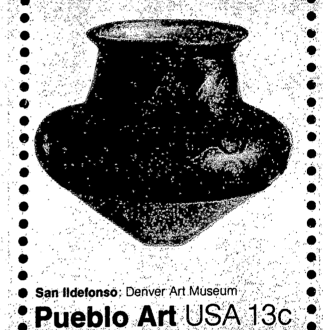

San Ildefonso: Denver Art Museum

Pueblo Art USA 13c

Stamps very often are miniature pieces of art. Make sure your camera is square to the stamp so you don't distort its shape.

 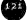

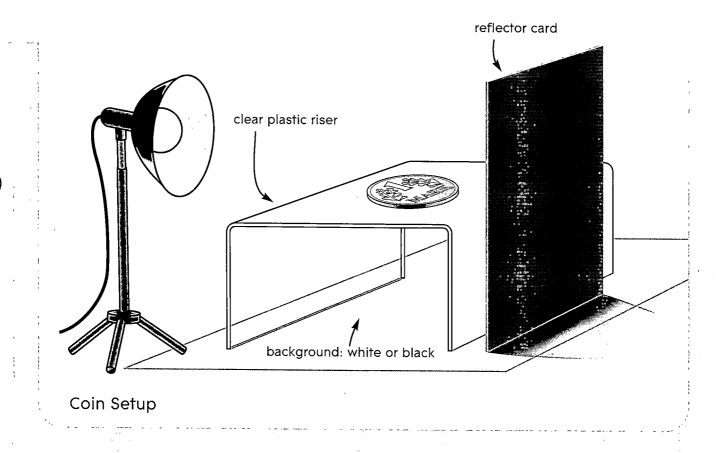

reflector card

clear plastic riser

background: white or black

Coin Setup

Coins are all about surface. The Ellis Island silver dollar is an example of what I mean (opposite page). A coin needs to be lit with strong sidelight to bring out the bas-relief of the engraving. The Ellis Island coin was placed on a clear plastic riser set over a large piece of black paper. A single tungsten light in a reflector was positioned about two feet (.61 meters) from the left of the riser, at about the height of the coin. A large white poster-board reflector was then placed on the opposite side of the riser. To emphasize the embossed image, I moved the light until I got the engraving to stand out. The camera was positioned over the coin and parallel to the coin's surface. I centered the coin with the markings in the viewfinder display so it would stay round in the image.

I shoot coins on risers because a single light source casts a dark shadow, and the riser allows the shadow to merge with the black paper below. Since the coin is not on the background paper, its edges won't be lost. Had it been placed on the black background paper, the coin's shiny rim would reflect the black and merge with the background.

The Ellis Island Standing Liberty silver dollar jumps out of the background (a plastic riser over black paper). I used a white reflector card that caused the smooth portion of the coin's shiny surface to create this "positive" image.

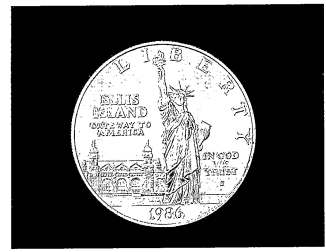

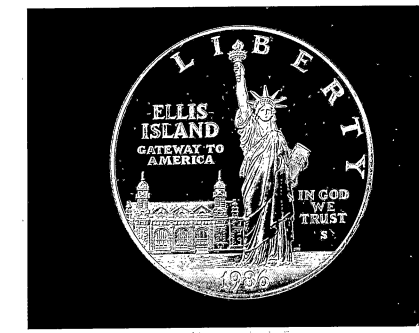

A black reflector produced this "negative" image, which makes the letters and illustration stand out against the darkness of the smooth surface area.

I shot the Ellis Island dollar two different ways to demonstrate the effects you can produce with a reflector. For the "positive" image, I held a large white poster board over the coin. As with silver jewelry, the card gives the shiny surface of the coin something to reflect. I moved the card until I could see white reflected in the coin's flat silver surface when looking through the viewfinder. For the "negative" image illustrated above right, I held a black poster board over the coin. The flat surface reflects the black board while the raised, curved areas pick up the light from the studio light.

A copy stand can be a helpful and time-saving investment if you do a lot of stamp and coin photography. It has a baseboard, camera post, and usually two to four light fixtures. Generally the camera is mounted on a sliding arm, which can then be set to any height along the post. The coin, stamp, or other subject is placed on a background on top of the baseboard, and the camera raised or lowered until the subject fills the frame. Though copystands are useful, it is

difficult to look through the viewfinder when the camera is mounted on the stand's vertical post, pointed down. Copy-stand work is infinitely easier if your LCD monitor can be extended from the camera and rotated so it is facing you. Some D-SLR systems offer right-angle viewfinder accessories for this purpose.

 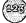

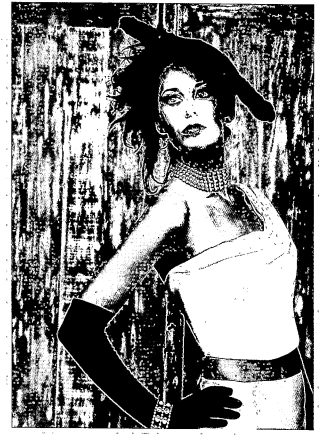

The weathered background in this photo makes an interesting counterpoint to the model's non-traditional wedding dress. Look for unusual settings that work well with the clothing when photographing outdoors. This picture was a team effort, including a stylist, hair dresser, makeup artist, and an art director—not to mention the photographer and model.

Using Models for Wearable Art

Shooting models and clothing can present certain challenges, but when the design and shape of wearable art is crucial to appreciating the work, then it calls for using a model. A good model can energize a photograph, but he or she can also end up being a distraction: A great looking model tends to take the focus of the photograph away from the object you are shooting. And remember that photographing models may require a team of people, like makeup artists and hair stylists. If you don't have a team, who is going to deal with these concerns? Worse than a distracting model in a picture is a distracting model with bad hair!

Finding the right model is not easy. Not all are fluid and natural. Their look must be appropriate for the style of the work. A big bearded guy who looks rugged and outdoorsy in a leather jacket may look like a beach bum in a hand painted flowery silk shirt.

You should use paid models when you need professional results. If you choose to work with family, friends, or other nonprofessional models, expect to get results that look amateurish. This may be OK depending on your expectations. But remember that viewers will compare your pictures of models to all the photos they've seen in glossy magazines of top professionals.

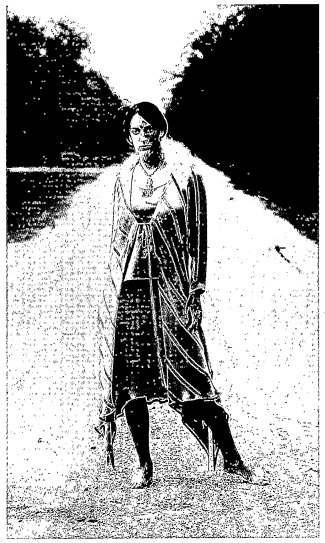

I prefer overcast days when shooting out-
doors because the softer light works well
with fabrics. This photo has a strong triangu-
lar composition with the road, sky, and trees
all forming small triangles. The model's face
and legs form another triangle. A number of
compositional elements have come together
to make a strong fashion image.

Weather conditions are of course important. Bright sunlight
is harsh and does little to flatter clothing. A slightly overcast
sky provides soft, diffuse light and means you don't have to
worry about harsh shadows or washed-out highlights. The
model's skin tones often look better too. But sometimes an
overcast sky can be too dark, and colors go flat. This is when
the camera's built-in flash can be set for fill flash to brighten
the picture.

Fashion photographers shoot with long lenses both outdoors
and in. Long focal lengths flatten perspective, an effect that
is helpful for this type of photography. When using a long
lens, a tripod is usually necessary for sharp pictures.

Outdoors

A lot of photography of clothing can be done outdoors with
natural daylight. To elevate outdoor shots above mere snap-
shots, carefully select the setting, composition, and the way
you use the existing light. Before you shoot, scout for loca-
tions. Look for colors in walls and surfaces that will work
with the clothing you are shooting. Avoid settings that are
busy and distracting. Keep it simple and don't use back-
grounds that are ugly, like aluminum siding and industrial
buidings.

In the Studio

Indoors, a larger version of the basic studio works well. At
least two lights and a backdrop are necessary. You have to
have enough room for two people (model and photographer)
to move amidst camera, lights, and background material. The
minimum indoor working studio space is a room 12 x 10 feet
(3.66 x 3.05 meters). In fact, if you plan to use models, often
the best arrangement is to have one large room for shooting
and a second, smaller dressing/make-up room.

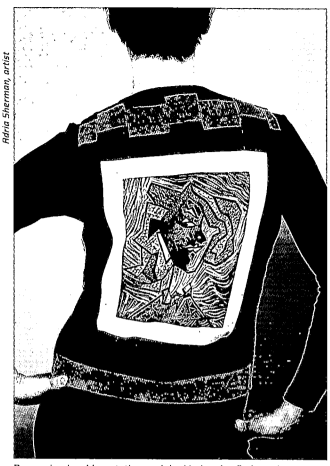

Adria Sherman, artist

By moving her hip out, the model added a nice S-shaped curve to this sweater.

Photographing models calls for a lot of lighting. I prefer to light models with studio electronic flashes because of their short bursts of light. The flash stops motion. This allows the model to move about freely. When I see a position I like, I take the shot. Tungsten lights can be used, but the light is continuous, not crisp like flash, so you have to keep telling the model to hold their position. This can take the spontaneity out of the shoot. Tungsten lights can get uncomfortably hot in small studio spaces.

When photographing clothing (or jewelry), have the model look out of the frame and avoid eye contact with the viewer. When we see a face, the first thing we do is look into the eyes. This draws us away from the subject of our photo, which is the clothing. Sometimes it is best to leave the model's face out of the photograph.

Clothing may look good on a model in person, yet appear flat in a photograph. So review your clothing photos in the LCD monitor. Playing images back gives you on-the-spot feedback for making adjustments to pictures. And models need feedback too. They often figure out what to do to make the photographs work when you show them the images. I often shoot a dozen frames and then sit with the model to review what we've done. I play back the images on a little TV set I have in the studio, using a cable connected to my camera. That makes it easy for two or more people to see what has been shot. I may then decide to change the lighting, or the model might think of additional poses and movements that will show the work. That's when a professional model really earns his or her money.

Model Releases

Be sure to explain to your model how you plan to use his or her photographs. And even more importantly, do not fail to get a signed release whenever you work with a model, whether they or being paid or are working for free. A model release is a contract that gives you the right to use the photograph for marketing and other commercial purposes, including placement in brochures, publications, advertisements, and on websites. By signing, a model acknowledges that he or she knows how photographs of them may appear in public. Model releases specific to different states can be found through a search on the Internet. They are absolutely necessary to protect both the photographer and the model in today's litigious environment.

Objects That Light Up

Lamps and candelabras and other objects with lights need to be photographed when lit–an unlit candle or dark lamp makes a rather dead image. Start by setting the work on the background and turning on its light (or light its wick). Then turn off all the room and/or studio lights and take an exposure reading by placing the camera close to the light. The light should fill the viewfinder if possible. Do this with the camera in the M, S, or A exposure modes. Set the white balance control to tungsten (usually the light bulb icon). Although candles produce warmer light than tungsten bulbs, this setting will keep the color from becoming too red.

Note: When photographing a candle flame, it's absolutely necessary to turn off fans, air conditioners, and heaters that might create air currents that will blow the flame around, blurring its image.

Next, turn on the studio lights and move them to different positions until a meter reading indicates an exposure one stop lower than your lamp or candle. For example, if a candle flame requires f/5.6 at 1/30 second, I want the overall scene lighting to be f/5.6 at 1/60 second. Take a picture at this setting and see how it looks. The idea is to create a natural looking image with the light glowing a little brighter than the object. If I'm unhappy with this first image, I delete it, and move the lights again.

Jim Mullan, artist

By carefully measuring the light produced by the lamp in the truck cab and balancing the external lighting to a slightly lower level, I produced a very natural looking image.

Galleries and Museums

It is always exciting to have your artwork in a gallery or museum, and it's definitely worth documenting the show. The first step is to ask permission to take photographs, and the second is to clearly explain how you plan to use them. Often you are not permitted to use extra lighting, even small on-camera flashes, in a gallery or museum. To work around this restriction, plan to use a tripod and set the ISO to a higher sensitivity than usual. Also set your white balance for the dominant source illuminating the art. If the artwork is lit by a tungsten spot, set the white balance to tungsten. If the piece is near a window, try using the daylight setting.

Sometimes tungsten spotlights highlight the art, but the room is lit with fluorescent lighting. The fluorescents put a green cast into the picture's shadows that are difficult to fix with image-processing software. One way to resolve this problem is to ask for the room lights to be turned off. You can try setting the camera to manual white balance (sometimes called custom or preset) and take a reading off a white or neutral gray card for accurate color correction.

Since you will often be shooting long exposures in dimly lit spaces, it is a good idea to use a remote release to avoid blur caused by camera shake when you press the shutter button. If your camera doesn't have a remote release, use the self-timer to allow the camera to settle down after pressing the shutter button. You will need a moderate telephoto setting on your lens for shooing individual pieces and a wide-angle setting if you plan to shoot images showing the museum's or gallery's interior space.

Remember to disable the camera's built-in autoflash when shooting in a museum. Some cameras may require you to turn the flash off after each frame, or each time the camera is turned back on.

courtesy The Preuit Collection

05

the digital darkroom

○ ○

Even when you have carefully controlled the lighting and set your camera according to its meter readings, you'll sometimes need to enhance or alter the image files you've made. Most pictures can benefit from at least a bit of image processing in the computer, or what is sometimes called the digital darkroom. There are a number of programs available. For a decade, Adobe Photoshop has been the standard for photo-processing programs, though there are a number of others, including Adobe Photoshop Elements (a scaled down version of Photoshop), Picasa, Ulead PhotoImpact, Corel Paint Shop Pro, and Apple Aperture.

Enhancing Digital Image Files

These programs use similar tools to perform many of the same image-processing functions. After downloading your image files, usually to your hard drive, browse and select the photo you want to enhance, bringing it into the program's work space. I suggest you work on duplicate files and keep your originals safely stored somewhere on your computer, external hard drive, or a CD/DVD. These originals are your "negatives."

Most programs have automated tools with names suchs as auto contrast, auto color correction, auto levels, smart fix, etc. With one click these tools will assess the image file and make alterations. These tools are quick, but they give much less control over adjustments than other tools that are slider-driven, which allow finer control over how much contrast, brightness, or color saturation to add or subtract, for example. Use these sliders, watching their effect as you move them to make changes to your digital file.

Often you can see a preview of what the effect will be before actually making the change, or toggle back to what the file looked like before enacting the adjustment.

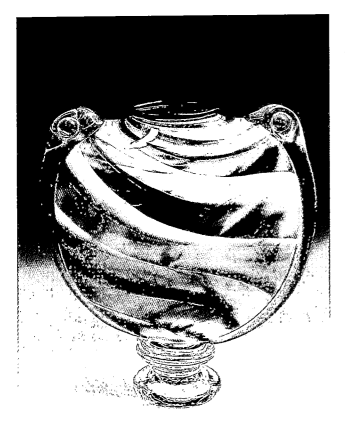

Skillful use of the clone tool can be invaluable when processing your photos in the computer. In the original image file (left) of this glass vase, there is unwanted glare near the top of the glass vase. You can copy pixels from another portion of the image file and place them over the hot spots (below) to replace the washed-out areas.

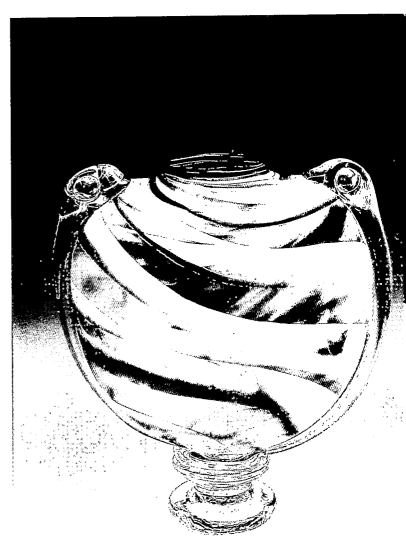

Mark Rosenbaum, artist

DON'T PANIC!!

What if you make a change to your image file that you don't like? First off, if you are working on a duplicate file, you always have the original intact. But nearly all changes in these programs are "undoable." In fact, the command to go back to the file before the change was made is often called Undo. You can even return several steps back to previous versions of the file before changes, often to the point of opening the file before any changes were made. It's only after you deliberately save changes that you can't undo what you have done!

Common Software Functions and Tools

What happens when you use the selections in these programs to make changes to your picture files? What tools and menus are you going to use most to enhance your photos of art pieces, crafts, and collectibles? Let's take a brief look at what can be accomplished. This is a general overview that looks at only a few of the functions found in these software products–use the program's user manual or any of the many instructional books available for more information.

You can make colors more vivid with Hue and Saturation controls.

Zoom Tool

Often shown as a magnifying glass icon, this tool enlarges or reduces the size of the image you are processing inside the workspace. Use it to see the entire picture when adjusting controls such as color or brightness. Zoom in when you want to perform subtle, detailed image processing like cloning.

Crop Tool

This lets you reframe a portion of the image you want to crop, eliminating the portion outside the crop lines. You can adjust the rectangular cropping frame to any proportion in terms of height and width).

Louise Hill, artist

Clone Stamp

Another extremely useful tool, the Clone Stamp allows you to replicate bits of the digital image to replace other parts of the photo. Use cloning to fix blemishes and replace faults that appear in your picture.

Color Adjustments

There are often several dialog boxes or drop-down selections that help you adjust color when it doesn't look exactly the way you want in your photos.

Adjust Color Cast: This is a white balance control that allows you to click on a part of your picture that should be white but is showing a color cast, restoring it to white. Other colors in the picture will shift correspondingly.

Adjust Hue: This is often a slider or value that can be changed to alter the overall coloring of the picture, or some selected colors in the image.

Adjust Saturation: This increases or decreases the intensity of colors in the photo.

Brightness Adjustments

Levels: This is a valuable control that allows you to adjust the tonal contrast of the picture. It is a histogram with sliders that lets you separately adjust the distribution of shadows, highlights, and midtones to the overall image file, or to the red, green, or blue color channels separately.

Brightness: This slider will add or subtract brightness, making the entire image darker or lighter, which also increases or diminishes the intensity of the colors.

Contrast: You can increase or decrease the difference in brightness between the light and dark portions of a photo.

Sharpness

There can be several adjustments to help with digital sharpness, but one is usually used more than others.:

Unsharp Mask (USM): This controls the contrast between edge pixels where tones meet as a way of increasing the apparent sharpness of the picture. Making adjustments, you can reach a point where a halo forms around the lines of contrast and the picture will not look natural—a sign that your are oversharpening your picture. You can move the USM sliders back to reverse the over-sharpening process.

This is the window and dialog box for resizing images using Photoshop Elements. Notice the fields for Pixel Dimensions and Document Size, as well as the check boxes for Resample Image and Constrain Proportions.

Image Size/Resize

This is an important tool that you should understand. When you shoot an image, your camera will store it at previously defined resolution specifications. By resizing with your image-processing program, you can change the resolution of the file. Of course, increasing the resolution will decrease the height/width dimensions of your photo, and vice versa. In this way, you can adjust images to become the optimal resolution for printing, for a PC slide show, for website use, or emailing.

The Image Size dialog box shows you the total file size in megabytes, the pixel dimensions, the height and width dimensions, and the resolution. The resolution needs to be adjusted for specific uses. For instance, if you are submitting an image for print publication, the image resolution should be set to about 300 ppi. For your own prints, 300 ppi is great but resolutions as low as 200 ppi may still produce sharp results. For the web, computer monitor, or digital projection, resolution should be only 72 – 96 ppi.

To change the resolution, uncheck the Resample box and input the resolution you want. At 72 ppi, the document size for an 8MP image will be 45 x 34 inches (114.3 x 86.4 cm), which is way too big for a PC screen. However, set the resolution to 300 ppi and notice that the document size will change to 10.9 x 8.2 inches (27.7 x 20.7 cm).

After adjusting the resolution, you can also adjust the height and width dimensions downward to best fit a particular use. Check the Resample box and input a value (in inches or metric) to either the height or width box (when you type one dimension for height or width, the other number will automatically change if the box for Constrain Dimensions is checked). The file will retain its resolution, but will print at the reduced specifications for height and width.

Interpolation: This is a process that applies mathematical algorithms to an image file. The program will increase file size by analyzing existing pixels and creating new ones to fill in between the existing to achieve a higher resolution. For example, if there are two blue pixels next to each other, the software will add a third blue one to make the file bigger. If you have a 300 ppi file that is 5 x 7 inches (12.7 x 17.8 cm), you can increase that file to be 300 ppi at 6 x 8.4 inches (15.2 x 21.3 cm), or another proportional size. You interpolate a file by checking the Resample box and inputting new values to the height or width box. Interpolation is tricky and it has limits. Its best to increase file size in increments of 10% and then examine the image for broken lines or blurred areas.

Layers

Layers is a valuable and powerful function that allows you to add dramatic or subtle revisions to portions of image files while leaving other portions unchanged.

Entire books could be written about methods to effectively utilize layers in these software programs. To give you an idea of what layers are, imagine a stack of clear acetate pages. As you add a layer to your original image file, it is like placing a sheet on top. You then perform your processing on that specific sheet, leaving the sheet beneath it untouched. You can turn these layers on or off as you wish to add or subtract revisions and effects to your original image file. When you are happy with all the layers, the changes you have made are applied to the file with a click of the mouse.

Correcting Distortion

If the camera is not perfectly positioned when you photograph a rectangular shape, the rectangle's corners will not be perfectly square. In fact, one side or another will be longer or shorter than the other sides. Image processing gives you the ability to correct this type of perspective distortion. This keystoning can occur with any rectangular (or square) object, like paintings or stained-glass windows, making the sides appear to taper toward each other rather than remaining parallel.

Remember to work on duplicate images. Use the Transform control, which in Photoshop Elements offers several options in a dropdown menu. Select Perspective or Distort from these choices. You will be asked to create and name a new layer. I usually use the default name and click OK.

Perspective will create a frame on the layer in which eight toggle points appear around your image. Pull on one of the corner toggles and the image will tilt in that direction with parallel sides moving simultaneously. With a little experimenting and practice, you'll get the hang of correcting perspective and eliminating keystoning.

The Distort option is similar, but now each toggle pulls only the side or corner it is near, which allows you to correct complex distortion. For instance if you are shooting a painting from below with the camera is not parallel to the object, the lines in your image will not be parallel. The Distort control allows you to correct this. But just like the Perspective control, you need to practice using it with images to see how each toggle works. Once you've fixed the image, press the Enter key and the changes are set.

Saving Images

After you've worked on a duplicate of your image, you'll need to save it. Make sure when you opened your duplicate file for processing that you gave it a name different than your original. If you did not, then use the Save As command to rename the file so it is not confused with your original photo file. This command also lets you select the storage location as well as the file format.

If the file you have processed might be made into a high-quality print at any time in the future, save it either as a TIFF or in the native format of your program (e.g. PSD for Adobe). Because of the way JPEG discards digital information during compression, then rebuilds when opened, resaving files in JPEG can lead to degradation of your images. If you are saving your files strictly for Internet use or for emailing, you can save them as JPEGs since they need to be smaller and lower resolution.

Remember that saving images on your hard drive not only uses memory, but also means you may lose all of your images in case of a computer crash. Saving images on CDs or DVDs, or backing up your images on an additional external drive, is a safer way to save and protect your photo files.

Printing and Displaying Images

Most new inkjet photo printers are able to print pictures directly from the memory card using the PictBridge technology standard. This can happen in several ways: by docking the camera on the printer, connecting it with a USB cord to the printer, or by putting the camera's memory card into a slot on the printer. It is a simple way to get 4 x 6 inch (10.2 x 15.2 cm) prints, but it's not the best way to make bigger, high-quality prints. For the best possible color prints, you need to use an image-processing program to prepare the image and control the printing parameters.

To do this, open the image file you want to print in the workspace of your processing program and resize it to the resolution you want—I often use 175 – 250 ppi (make sure the Resample box is unchecked). Inputting a value in the Resolution box will automatically set corresponding values in the Document Size boxes for Height and Width. A file set at a resolution of 175 ppi will make a larger print (document) than the same file set to a resolution of 250 ppi, but the pixels will not be as close together, so the details of the print may not be as sharp.

I like to check the image in Print Preview, which allows me to see what the photo will look like and how it will be positioned on the page. You can then reposition it on the page if you choose. When satisfied, print the photograph.

The print preview screen allows you to scale the size of your photo, rotate it, and place it so it fits where you want it on your printing paper.

Your document size will be dependent on resolution, and will vary according to how big the recorded file is, which is affected by factors such as sensor size in megapixels and recorded image quality. If you set the resolution for 250 ppi, you might get a document size of 5 x 8 inches (12.7 x 20.3), as an example. You can make the image size bigger and still retain a resolution of 250 ppi by interpolating the file (see page 135). However, too much interpolation can lead to unsharp images with flaws.

Proof Sheets

Image-processing programs usually offer the ability to make and print proof sheets, with thumbnail (small) images arranged on a single sheet. In film photography a proof (or contact) sheet was the way to see all the images from a roll of film on one piece of photo paper. Digital proof or contact sheets are a good way to keep a visual record of your images, and they make it easy to find a particular image to print or put up on the web.

A good way to know what photographs are in your image library is to save images on CDs and print proof sheet for each disk. The disks and pages can be stored together in a loose leaf file. When I need to find an image, it is a lot faster to thumb through the proof sheets than to load and view each disk. It is an old technology solution to a new technology storage system.

A number of image-processing programs include a file management function that allows you to label your image files and organize them into different albums. Stand alone programs are also available to do this. Among the many handy features in these cataloging programs, they make it easy to move photos from one storage file to another, search for photos according to different criteria such as key word or date created, and print the album as proof sheets.

Images for the Internet

When it comes to viewing pictures on the Internet, speed matters. You want your photos to be accessible to as many viewers as possible, including those still using low-speed dial-up systems. Even for viewers who have high-speed connections, very large files will take too long to download. Folks on the web want things fast, and that means image files that are sized properly. A 50 – 60 kilobyte (KB) image file that is 640 x 480 pixels at 72 ppi is the standard for web photographs. It's big enough that on most monitors it will produce an image that largely fills the screen.

When shooting digital images specifically for the web, set your camera to its lowest JPEG resolution with a high level of compression (lower quality). These small files should require little or no resizing. If you have existing large files that you want for Internet usage, resize them to reduce the pixel dimensions and resolution. Keep the original files intact, and save the new files as JPEGs with new file names. Increase compression (decrease quality) by moving the appropriate slider until the file size is approximately 50 – 60 kilobytes (KB). At this size the download time is just seconds even with the slowest modem, and instantaneous with a fast modem. Files for thumbnails to display on a web page should be even smaller. Resize thumbnail images to be about 150 pixels wide and save as JPEGs. These will appear about two inches (5.1 cm) wide on most screens: Big enough to see well, small enough to load fast.

Photos for
Internet Auction Sites

Good photographs for auction sites like eBay are essential for selling items, and they are different than the image files you would create for jury submission or to show on your own website. Auction pages are easiest to read when dark text and images are placed on a white or a light color background, so follow that common layout rule and shoot your items for auction on light backgrounds.

The average Internet auction page usually has 2 – 4 pictures. The first and most important is the "money shot." This is the photo that draws buyers to your page, and will appear on the gallery page, the search page, and the auction page. Set your item up on a white or light background and use the techniques we've discussed to shoot sharp, detailed, and well lit photos. In the money shot, the entire item should fill the frame as much as possible. The photo of the entire antique clock (opposite page, top) illustrates this.

With the clock auction page, I'd have a second image showing the back of the clock (opposite page, bottom) plus a third and fourth image that are detail shots. In the case of the antique clock, I'd use the close-up of the clock face (above) and of the engraved spring mechanism (left) as the detail shots.

These extra photos show the bidder more about the item. Even if the site allows more, I think 4 – 6 photos are plenty for most sale items. You may want to show other sides of the object, additional important details, and any flaws or damaged areas (to be fair to the bidder and to protect yourself from an angry buyer who could leave nasty feedback).

If you are selling two-dimensional items, beside the money shot, there should be another picture that shows an important detail of the work or style used to produce the piece. This should convey something about the technique or the materials used to give the buyers a better sense of what you are selling.

Internet auction sites often size images at 400 x 400 pixels. Big files get resized by the auction software, and sharpness can easily be reduced in this process. When submitting photos to auction sites, I resize the longest dimension of the file to 400 pixels and use Unsharp Mask to sharpen the image.

I shoot lots of images for each photo I plan to display when preparing an auction page, and view them as 3 x 4 inch (7.6 x 10.2 cm) images on my monitor. I do this in the image-processing workspace by simply clicking on the zoom tool until the images are about that size on my monitor. This shows me how they will look on the auction page. Viewing them at this size makes it easier to choose the best photographs.

Once pictures are placed and uploaded, most sites provide a preview of the auction page(s). When I get to the preview, I take a second look at the pictures to make sure they've loaded properly and the photo I've wanted as the main photo is indeed in that position.

Preparing a Jury Submission

While speaking to a group of artists a while back, I was asked to explain what jurors are looking for when selecting photos for submission to shows and exhibitions. Although I can't speak for all, I know what I want to see when I jury a set of submissions. These qualities are also the ones you want to convey when putting images on your personal website.

Originality

The originality and creativity of a work should stand out. The uniqueness of your art is what you have to sell—it's what distinguishes you. Photos have to show the distinctive nature of your art pieces, because jurors are usually looking for a creative talent to exhibit in their shows. As a juror, I look for work that surprises me, wows me, amuses me, makes me think, or inspires me. Don't be afraid to show your originality!

Craftsmanship

The photography should illustrate your technical skills in creating arts and crafts. I once had to reject an elegant silver bracelet because I could see burn marks and production scratches in the close-up image. Don't expect to cover or hide imperfections with image-processing software techniques. Always pick well-made and well-finished work to photograph.

the digital darkroom

Style

A set of images, whether for jury submission, for display on a website, or for publication in a brochure, should have a sense of unity that connects them as a body of work. Your style should be recognizable through common elements of color, design, or technique.

Judging

Even the most creative artist with a high degree of crafts-manship and a strong body of work won't be able to please every juror. People's taste in art comes in all flavors, and what one juror finds great may not please others. Don't be discouraged. No one gets into every show and exhibit. Be smart and research before applying. Get a sense of what the judges have chosen in the past and tailor your submissions to appeal to them.

Ron Lentz, artist

Digital Image Submissions and ZAPP

More and more shows and art exhibitions are accepting jury submissions by email. There are advantages to this because jury by slide always required a great deal of handling: open-ing packages, taking slides out of their sleeves, loading them in projectors, returning the slides to the right artists, etc. All this physical activity created many opportunities for damage and loss. Digital entries eliminate these problems because they are electronic copies that are easily organized and don't have to be returned to the senders. This makes things a lot easier for the show and exhibition staff.

There are a couple of different file systems available that are designed to handle email submissions of this type. One that works well with images viewed on a computer monitor is eJury. But these digital images don't always look as good when viewed as projected images. Horizontal photos will fill the hori-zontal frame of a digital projector, but vertical images will appear small because they fill only the center third of the pro-jected frame.

A solution to this problem is the ZAPP format, which proj-ects either horizontal or vertical images within a square can-vas. You can read about ZAPP files and procedures for uploading images at their website, www.zapplication.org.

This is an image in a
ZAPP format frame

Adding Copyright Information to Digital Images

You are probably well aware of the steps you should take to protect ownership of the idea and design behind your piece of art or craftwork. But you also want to protect the image (photograph) of that artwork as well. Once you put something on the World Wide Web, it cannot be completely removed and there is no way to control how it will be used by other people. From anywhere on the planet at anytime of day, there are few limits to the instant accessibility of images on the web. Of course you can't stop someone from looking at your images and copying them, but you can erect some barriers that will help.

One way to reduce the utility of pictures is to make them as small as possible. An image that is uploaded to the web as a small JPEG is basically unprintable and hard to misuse. While a 2 x 1.5 inch (5.1 x 3.8 cm) thumbnail looks fine on screen and clearly shows your work, it has little commercial value because it is far too small to print sharply.

But small files defeat one of the main reasons to be on the web in the first place. They have far less impact and power to sell your work than larger images. To help protect larger images, you can affix a copyright notice to each image you load on the web. The notice not only protects you from the illegal copying and misuse of the image, it gives you a date of creation. In many copyright lawsuits, the date of origination of a photo or other creative work is crucial to successfully defend the copyright.

The simplest way to add a copyright notice to an image is to use Adobe Photoshop or a similar image-processing program to add text to the picture file. After opening an image in the program, find a text-box tool or command and type "photo©20xx your name" in the box. You are usually given the option to select a font style, font size (keep it small), and color for the text. Move the text box with the mouse to place the copyright notice where you want within the image, and save.

This type of copyright notice is visible on the image and may obscure a part of it. If you choose to use a small font size and put the notice in an inconspicuous part of the image, it might be easy to crop the notice out of the image, thus defeating your original purpose.

The best way to protect your digital images is by creating an invisible copyright notice using software that produces "digital watermarking." These can be stand alone programs or plug-ins for your existing image-processing program, and they embed the copyright notice throughout the image where it remains unseen until someone tries to copy or manipulate it. Sometimes these watermark programs let you add information to the embedded file, such as address, information about the object, or date the work was created.

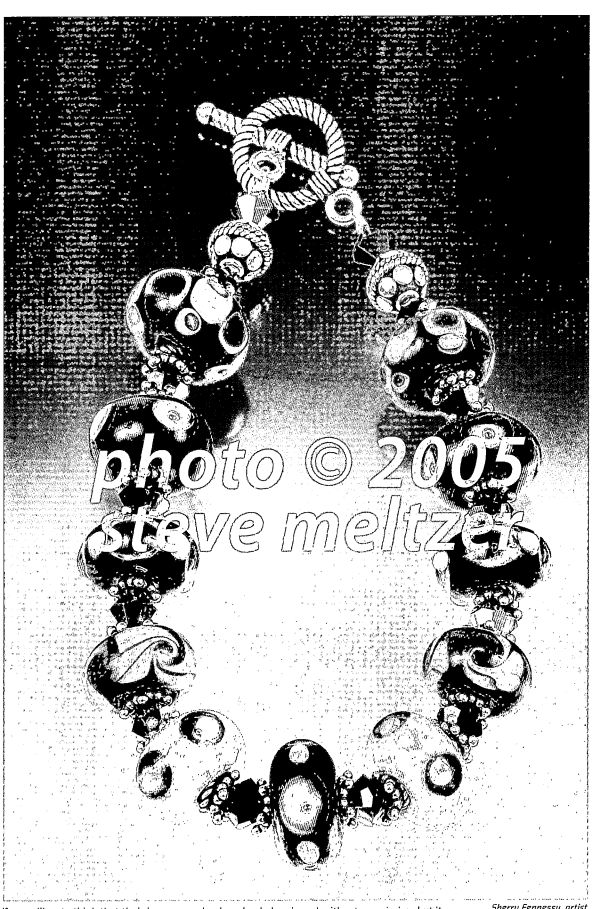

Sherry Fennessy, artist

No one likes to think that their images can be downloaded and used without permission, but it can happen in the digital world. You can add text (as above) or digital watermarks that make your images less attractive to those who might want to use them for their own purposes.

troubleshooting and camera care

● ● ● ● ● ● ● ● ● ● ● ● ● ● ● ● ● ● ●

A fundamental truth is that the more foolproof anything is, the cleverer fools become in figuring out how to mess up. I know—I'm one of those fools. No matter how foolproof a digital camera may be, I always find a way to make mistakes.

Here's a short list of common problems I've encountered in digital photography and a few ways to resolve them.

Subject too Small in Picture.

The viewfinders on many cameras don't show 100% of the picture area. If this is the case with your camera, you'll see only about 90 – 95% of the total area when you frame an art or craft piece. That means you'll end up with some extra space around your subject in the resulting image. Of course you could crop this extra area in image processing, but it is best to get as much subject as possible on the sensor. Learn to frame the subject in the viewfinder so it appears larger than you think it should. Experiment until you have confidence about how much of the frame is filled without overdoing it. And remember that many LCD monitors let you see the full image before you take the photo. If your LCD shows the full image, use it to frame your pictures.

I framed this small pin according to the rule of thirds then closed in to take a test shot, making sure I captured the entire subject with no wasted space

Sherry McGilvary, artist

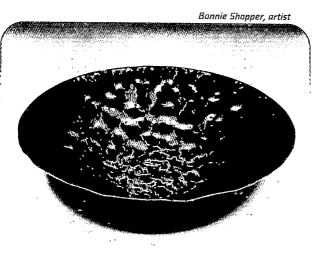

Bonnie Shopper, artist

When you start shooting object pictures, try taking a couple of frames using two or three different metering systems (spot, multi-segment, center-weighted) to see which one will give you the most accurate exposure.

Inconsistent Exposure

Learn to set the metering mode for specific situations. If you always leave the camera in multi-segment mode, large areas of light or dark within the image can lead to improperly exposed photos. For example, multi-segment metering will read a large white background and quite possibly underexpose the image, which makes the object appear dark. Conversely, a black or dark background throws the reading off in the other direction, causing the image to be overexposed. One solution is to switch the camera to spot metering and take several shots, changing the aperture setting for each one (bracketing). A number of cameras have autoexposure bracketing functions that you can set to do this.

Burnt-Out Areas, Hot Spots, and Glare.

Digital photographs, like color slides, have a limited contrast range. Overexposed areas record no useable date and become irretrievably washed-out. No amount of image processing is going to bring detail back to overexposed highlights.

Look at your setup and review a test shot in the LCD to see where the highlights and hot spots are. Softening the light can help reduce hot areas and glare. Most camera models have a histogram that will show the distribution of tones in your photo. If the tones are out of the sensor's range, adjust your exposure settings and/or exposure compensation and re-shoot.

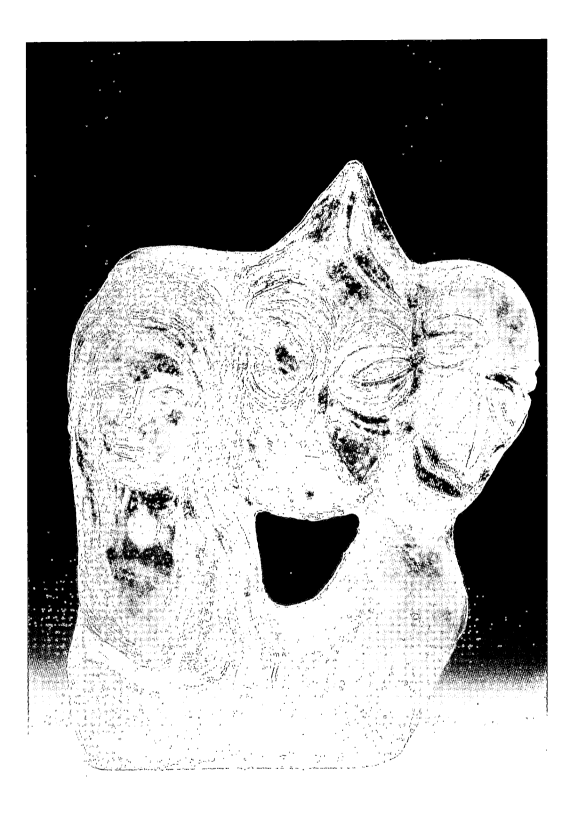

This is a high key subject—all light tones. By checking the histogram before shooting I could adjust the lighting to avoid extremely burnt-out highlights.

Laura Vincenti, artist

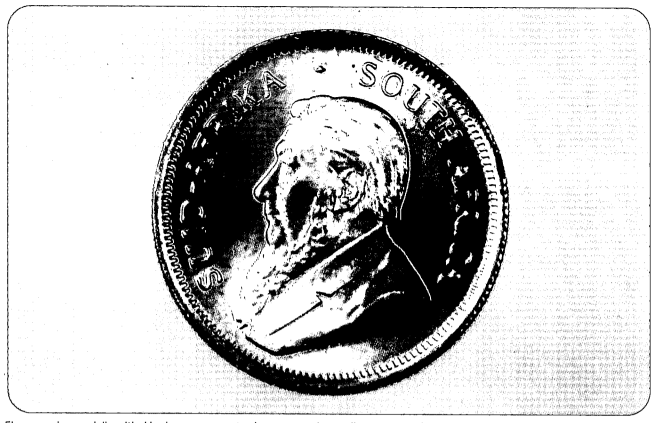

Sharpness is especially critical in close-ups, so a steady camera and a small aperture are important when shooting small, detailed objects.

Out of Focus Close-Ups

Some digital cameras offer a focus priority mode and won't fire if the camera hasn't focused properly. Others indicate when the camera is having trouble finding focus. This may be one of the most ignored signals in photography, but you should pay attention to it. Even if you camera confirms focus, certain portions of your close-up subject may look sharp while other areas appear soft or out of focus. This may be due to insufficient depth of field. Remember to use small apertures like f/11 or f/16 to make sure you have the depth of field needed to shoot sharp close-up images.

If your aperture is stopped down and you are still getting blurred close-ups, camera shake may be involved. When handholding the camera, shutter speed has to be fast enough to avoid camera shake–a rule of thumb states that the shutter speed should be close to the reciprocal of the focal length being used. If you are shooting with a focal length of 50mm,

your shutter speed should be 1/60 second when handholding the camera. If you are using a focal length of 100mm, you shutter speed should be 1/125 second. Some D-SLRs and some lenses have image stabilization systems that allow you to use shutter speeds that are a stop or two slower than the rule of thumb. Of course, the best way to avoid camera shake is to use a sturdy tripod and a remote release or self-timer setting.

In addition, sometimes autofocus systems don't focus well (or fast) in the relative low light of close-up studio work. Auto systems that focus by finding the point of greatest contrast between two adjacent points may not work so well when the scene has large areas of uniform surface, therefore lacking contrast. One solution is to switch the camera to manual focus. This helps, especially if you have a good viewfinder to help identify optimal manual focus. A trick that can help here is to place newsprint in front of the subject and focus on the text. This gives autofocus systems the contrast they need, and makes manual focusing easier too.

Color Cast

A mismatch between the color temperature of the light and the camera's setting for white balance can lead to inaccurate rendition of color. Auto white balance (AWB) can miss the mark. The solution is to select the white balance setting for your lighting, or to set white balance manually using a white or gray card (see page 35).

Moiré Patterns

M oiré is the appearance of wavy or crosshatched lines in patterned areas of an image. More prevalent when photographing subjects with fine, repetitive detail such as stripes or checks, moiré often occurs when the specific frequency of a pattern is finer that the resolution of the sensor.

Some moiré can be removed from the image during processing with anti-aliasing software, but whenever possible, try to prevent it by doing one or more of the following:

1. Change the camera's angle or position.

2. Change the point of focus and/or the aperture.

3. Change the focal length of the lens.

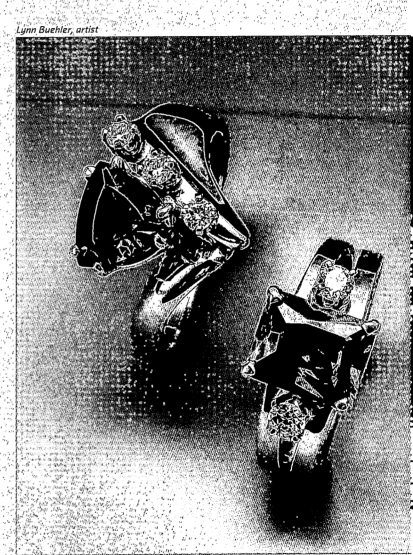

Lynn Buehler, artist

Color casts are most evident in the gray areas of an image so its critical to match the camera WB setting to the type of lights you are using, to ensure that the gray stays gray.

Lost Files

H ave you ever accidentally deleted a file or reformatted a memory card before downloading the files? I used to think that in these cases files were erased forever, but that is not usually the case. Instead, the computer notes that the file's space in memory is once again available to be re-used. The deleted file or reformatted card is waiting to be overwritten.

There are a number of software products that retrieve deleted files or those from reformatted cards, especially files that have yet to be overwritten. Some of the best known include RescuePro, ImageRecall, Eimage Recovery, Media Investigator, Media Recover, and Image Rescue. They are designed to retrieve information from a deleted file or a reformatted or corrupted memory card. They can also be used to delete data permanently, if that's what you want.

Digital Gibberish

I coined this term to describe the appearance of strange icons, weird messages, and unusual characters on the camera's LCD monitor—a kind of digital camera breakdown. Sometimes the camera may lock up and refuse to take pictures, or it may start writing corrupt files, or even stop writing files altogether. The simplest solution is to reboot the camera, either by turning it off, removing it's batteries for a few minutes, or using its reset button if your camera has one (usually a recessed button located on the camera's body). This resets all the camera functions to its factory defaults and, even though you will lose your existing camera settings, it will often take care of this problem. If rebooting or resetting does not work, you may need help from the manufacturer or camera repair shop.

Digital cameras are marvels of technology, but like any sophisticated electrical device, problems can occur. In the case of a camera "crash," try removing your battery for a couple of minutes and then reinsert it.

Caring for
Digital Cameras

Digital cameras are small computers and mechanical devices that are vulnerable to physical abuse (slams, bangs, and drops) as well as environmental insults (heat, moisture, dust, sea spray). Protect your investment by learning to take basic precautions to insure a long life for your digital gear. In fact, even a safeguard as simple as using a good camera case or a padded camera bag can save you a lot of repair costs.

Because the lens and monitor screen are regularly exposed to the elements, they are probably the most vulnerable parts of a digital camera. Lens cleaning kits that include a blower brush and microfiber cloth can be invaluable. When the lens' glass elements get dirty or accidentally smudged with fingerprints, they should be carefully cleaned with these tools. Blow off dust and clean the lens with a microfiber cloth or lens tissue. Use lens cleaner on the cloth if necessary. Wipe as gently as possible, never bear down hard. Also clean the barrel of your zoom lens occasionally because motorized zooms may drag bits of dirt into the lens cowling as the lens is extended and retracted. Also, a blower brush is a handy tool to remove these specks.

The LCD monitor can be damaged in a number of ways. This can happen when people put small cameras in their pockets or purses where they can get banged around and sometimes even sat upon. Get a small case for the camera and then put it in an outside jacket pocket. You can also get adhesive acetate screen protectors that cover the LCD screen to protect it.

Digital SLR cameras are most vulnerable to dirt when changing lenses. Even when turned off, the camera's sensor contains a residual static charge that attracts dust and dirt. It's best to change lenses quickly and place your hand over the lens mount when the lens is off. If you do get dirt on the sensor, it will show as little black dots in the same place in all your pictures. You can attempt to clean the sensor yourself on a D-SLR by exposing the sensor and very gently using a bulb blower, but be aware that this may void the manufacturer's warranty as well as cause damage to the sensor. Read your owner's instruction manual to see what it advises.

Many photo labs now offer professional sensor cleaning. The safest, though most time consuming, method is to send your camera back to the manufacturer for service. Some D-SLRs are now being manufactured with an automatic anti-dust or cleaning system.

Also use care when storing digital images. CDs and DVDs may only last 5-10 years, and the substrate material they are made of is easily damaged by humidity and moisture. The disk can be corrupted as the substrate corrodes. The cheap disks sold in giant office supply chains are often so poorly made that with even minimal use and handling they are damaged and files on the disks can be irretrievably lost. One remedy is to buy more expensive "gold plated" disks that are long lived and specially designed for recording photo image files. Once you've recorded a CD or DVD, put it in a sleeve or plastic jewel box. When you use disks, always hold them by their edges and carefully load them into your computer. I print a proof sheet for each of my disks and store them in a loose leaf binder along with the disks, which I keep in archival plastic sheets. This protects the disks and makes it easy to find images.

useful photographic resources

Photo Websites

About Photography (photography.about.com): Articles about choosing and using digital cameras, along with links to numerous photographic websites.

Apogee Photo Magazine (www.apogeephoto.com): Articles, interactive discussion forums, website links, and a database of photo schools, tours, and workshops can be found. For photographers of all levels, from beginner to intermediate to advanced and professional.

Better Photo (www.betterphoto.com): Articles about digital photography and image processing. A Q&A forum, listing of photo courses and resources, and a members' photo gallery.

CNET (www.cnet.com): A website that reviews electronic equipment. Choose the digital link to find market information about camera equipment and user reviews that tell you how things work in the real world.

Computer-Darkroom (www.computer-darkroom.com): For intermediate and advanced amateur photographers, this site contains articles, tutorials, reviews, and discussions for those who want to learn more about image processing.

Digital Photography Review (www.dpreview.com): Extensive coverage of the latest digital photographic equipment, including in-depth test reports and technical specifications. Includes numerous discussion forums and samples of images made with various digital cameras.

Imaging Resource (www.imaging-resource.com): News and equipment reviews, as well as numerous articles on equipment, tips, and techniques.

Luminous Landscape (www.luminous-landscape.com): Contains up to date articles and essays on the art and techniques of photography, as well as reviews, discussion forum, and product reviews.

Photo.net (www.photo.net): A popular discussion forum, the site also includes the opportunity to upload your images for critical review and rating. Member-written articles on digital photo topics, as well as camera/equipment reviews and shopping tips.

Steve's Digicams (www.steves-digicams.com): Camera reviews, news headlines and articles, and reader discussion forums.

Steve Meltzer (www.stevesfotos.com): The author's professional website with photos, rates, and contact information.

Take Great Pictures (www.takegreatpictures.com): Articles about equipment and techniques, as well as about celebrities who enjoy photography. Other features include photo contests, book reviews, a photo-events calendar, Q&A discussions, as well as suggestions for fun photographic projects.

Camera and Lens Manufacturers

Canon (Camera and lens manufacturer) www.usa.canon.com and www.powershot.com

Casio (Camera manufacturer) www.casio.com

Eastman Kodak Company (Camera manufacturer, accessories, and services) www.kodak.com

Kyocera (Camera and lens manufacturer) www.contaxcameras.com

Leica Camera AG (Camera and lens manufacturer) www.leica-camera.com

Mamiya America (Cameras and equipment) www.mamiya.com

Nikon (Camera and lens manufacturer) www.nikon.com

Olympus (Camera manufacturer and accessories) www.olympus.com

Panasonic (Camera manufacturer) www.panasonic.com

Pentax Imaging (Camera and lens manufacturer) www.pentax.com

Samsung (Camera manufacturer) www.samsungcamerausa.com

Sigma (Camera and lens manufacturer, accessories) www.sigma-photo.com

Sony (Camera manufacturer and digital recording media) www.sony.com

Tamron Inc. (Lenses) www.tamron.com

Tokina (Lenses) www.thkphoto.com

Toshiba (Camera manufacturer and accessories) www.toshiba.com

Vivitar (Camera and lens manufacturer and accessories) www.vivitar.com

Studio, Lighting, and Accessories

Alien Bees (Studio flashes and accessories) www.alienbees.com

Dynalite (Studio flashes) www.dynalite.com

JTL Lighting (Studio flashes) www.jtlcorp.com

Lowel Lights (Tungsten and electronic flashes) www.lowel.com

Lowepro (Camera bags) www.lowepro.com

LumiQuest (Flash accessories) www.lumiquest.com

Opus Pro Lighting Systems (Studio lights and accessories) www.opusprophoto.com

Photoflex (Lights, tents, reflectors, softboxes) www.photoflex.com

Slik Tripods www.thkphoto.com

Tabletop Studios (Lights and light tents) (www.tabletopstudio.com)

Tiffin (Filters) www.tiffen.com

Visible Dust (Sensor cleaning tools) www.visibledust.com

White Lightning (Studio flashes) www.white-lightning.com

Westcott (Lights, tents reflectors, softboxes) www.fjwestcott.com

Memory Cards

Delkin Devices www.delkin.com

Kingston Technology www.kingston.com

Lexar Media www.lexarmedia.com

SanDisk www.sandisk.com

Transcend Information www.transcendusa.com

Computer Hardware and Software

ACD Systems (Digital imaging software) www.acdsystems.com

Adobe Systems (Digital imaging software) www.adobe.com

Alien Skin Software (Digital imaging software) www.alienskin.com

Apple Computer (Computer manufacturer) www.apple.com

ColorVision Inc. (Color management tools) www.colorvision.com

Corel (Digital imaging software) www.corel.com

Dell (Computer manufacturer and accessories) www.dell.com

Digital Mastery (Photoshop seminars and training) www.digitalmastery.com

DisplayMate Technologies (Monitor calibration software) www.displaymate.com

Epson America (Printers, inks, and papers) www.epson.com

Hewlett-Packard (Printers, inks, and papers) www.hp.com

Iomega (Computer peripherals) www.iomega.com

Jasc Software (Digital imaging software) www.jasc.com

Lexmark International (Printers and inks) www.lexmark.com

Microsoft (Digital imaging software) www.microsoft.com/products/imaging

Monaco by X-Rite (Color management tools) www.xritephoto.com

Neat Image (Noise reduction software) www.neatimage.com

Nik Software (Digital imaging software) www.niksoftware.com

Pantone (Color management tools) www.pantone.com

Phase One (RAW converter software) www.phaseone.com

PhotoRescue (Software to recover lost image files) www.datarescue.com/photorescue

SmartDisk (Disk drives, scanners, cables) www.smartdisk.com

Ulead Systems (Digital imaging software) www.ulead.com

Verbatim (CD and DVD discs) www.verbatim.com

Artists' Websites

Kristin Anderson (www.kristinworks.com)

Antoinette Badenhorst (www.clayandcanvas.com)

Jack Becker (no current website)

Cheryl A. Boddy (no current website)

Lynn Buehler (www.jewelgallery.net)

An Cantor (no current website)

Scott Causey (www.scott.causey.com)

Barry A. Cohen (www.uniqueacrylicsculptures.com)

Marjorie & Dennis Collins (no current website)

Gloria H. Conwell (no current website)

Richard Cruise (no current website)

Ann Darling (no current website)

Marta England (www.martaengland.com)

Sue Fedenia (no current website)

Sherry Fennessy (www.sherryfennessy.com)

Robert Giordano (www.robertgiordanoart.com)

Michal Golan (www.michalgolan.com)

David E. Gonya (www.degonya.com)

Susan Goracy (www.e-jewelrybysusan.com)

Michael C. Harris (no current website)

Bess Heitner (www.bessheitner.com)

Louise Hill (www.louisehilldesigns.com)

Ala Jaron (www.alajaron.com)

Ron Lentz (www.ronlentz.com)

Jennifer S. McLamb (www.jennifermclamb.com

Sherry McGilvary (www.sherrylynnjewelry.com)

Dawn Mickel (no current website)

Jim Mullan (no current website)

George W. Nichols (www.nicks-wooden-pottery.com)

Nick Nixon (no current website)

Rick Ott (no current website)

Marcia Peterson (www.gardenfairies.com)

Felipe Packard/Ricardo de la Vega (no current website)

Pruit Collection (no current website)

Karen Reed (www.earthstarglass.com)

Angela Reichert (no current website)

Mark Rosenbaum (www.rosetreegallery.com)

Beth Russo (www.bethrusso.com)

Lori M. Sandstedt (www.lorimarsha.com)

Suzanne Shafer-Wilson (www.sswdesigns.com)

Adria Sherman (no current website)

Bonnie Shopper (no current website)

Laurie Stone (no current website)

Len and Laura J. Vincenti (www.leonardoglass.com)

Ainsley Walden (www.gofish-raku.com)

Kathy L. Watson (www.acpl.lib.in.us)

Louise Hill, artist

index